YANG SHAOBIN

This catalogue is published on the occasion of the exhibition
Dieser Katalog erscheint anlässlich der Ausstellung
Este catálogo é publicado por ocasião da exposição

杨少斌 **YANG SHAOBIN**
PRIMEIROS PASSOS – ÚLTIMAS PALAVRAS
FIRST STEPS – LAST WORDS 起步–结语

MUSEU DE ARTE DE SÃO PAULO ASSIS CHATEAUBRIAND
MASP | São Paulo, Brasil, 2009

YANG SHAOBIN

Edited by
Herausgegeben von
Editado por

UTA GROSENICK & ALEXANDER OCHS

With text contributions by
Mit Textbeiträgen von
Com textos de

*TEREZA DE ARRUDA and
SEBASTIAN PREUSS*

TABLE OF CONTENT
INHALTSVERZEICHNIS
CONTEÚDO

My style is a little bit forced.

Ich male ein wenig bitter und herb.

O meu estilo é meio amargo e áspero.

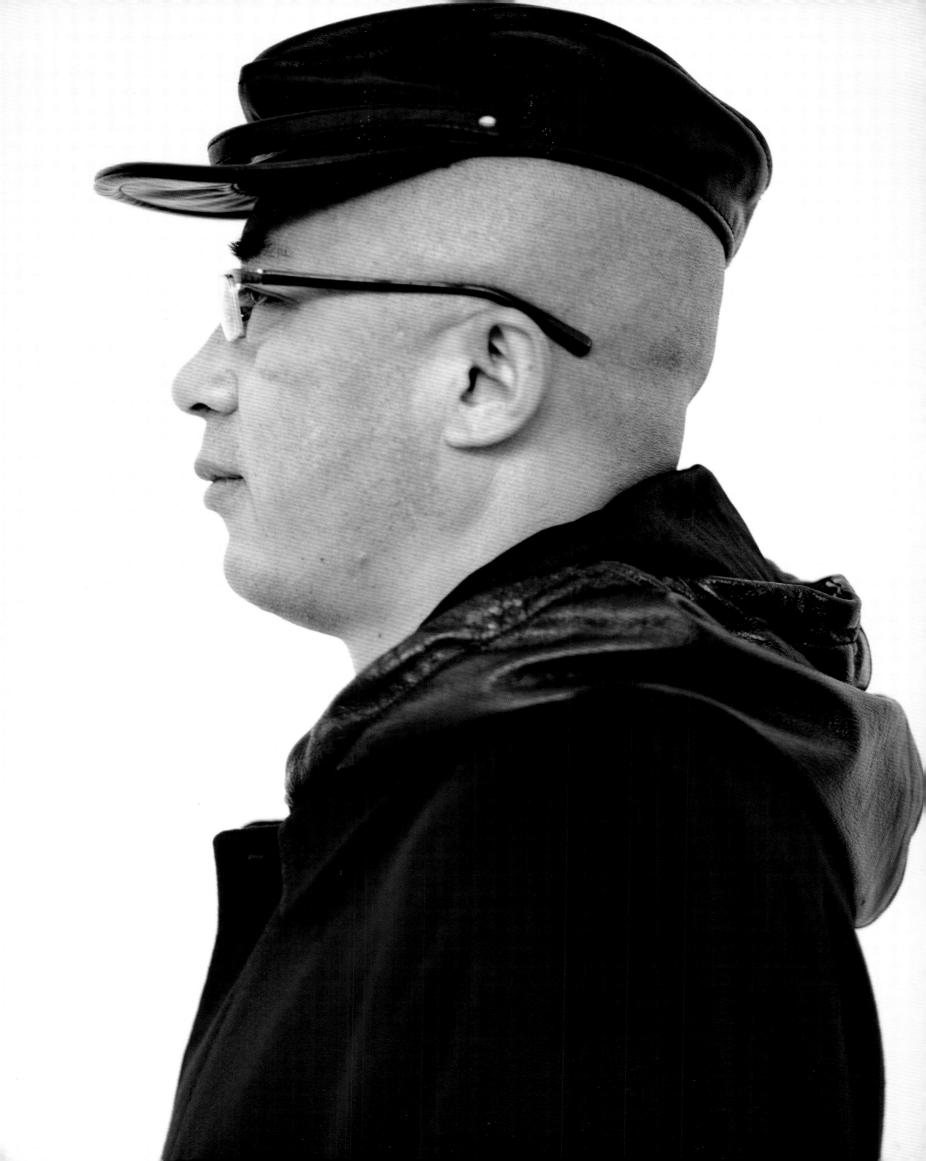

UTA GROSENICK & ALEXANDER OCHS

MARTIN KIPPENBERGER, YANG SHAOBIN AND OTHER YOUNG HEROES
MARTIN KIPPENBERGER, YANG SHAOBIN UND ANDERE JUNGE HELDEN
MARTIN KIPPENBERGER, YANG SHAOBIN E OUTROS JOVENS HERÓIS

Martin Kippenberger, today an artist posthumously celebrated in important exhibitions, left the now legendary club SO36 (which he then owned) on a rainy Berlin morning and walked into a veritable trap. Punks, friends of so-called 'Ratten-Jenny,' for whom Kippenberger was most likely a figure of elitist arrogance, awaited him, and beat him up. Kippenberger was brought to the hospital, where he staged a formidable picture, 'Dialog mit der Jugend' (Dialog with the Youth). The artist's head, bandaged and wearing a hospital cap, the ribbon of which is tied beneath his chin in a bow. His nose covered in bandages, the artists examines the manicured fingernails of his left hand.

Later, Kippenberger painted a small image of this state, and Yang Shaobin picks up this motif thirty years later. The artist represents the artist in monochromatic dark red colors, thus 'pacifying' the motif on the one hand, while on the other hand exaggerating it through its huge format; the ambivalence visible here has run through Yang Shaobin's work since the late 1990s.
He gives the work the title 'Strong Face (Kippenberger)' and thus creates for the first time a picture of an artist showing his injuries and a reaction to them.

Of course, violence and the engagement with violence has always been a central motif in paintings and sculpture of the Chinese artist: in older works, he struggles with his brother, with himself or artist friends like Fang Lijun: the same age, Fang Lijun and Yang Shaobin attended grade school together, and the former encouraged him to become an artist.

These pictures of fighting figures react the 'new period' in China, which resulted from the post-Maoist project of the Four Modernizations at the end of the 1970s. The Four Modernizations referred to agriculture, technology, economics, the army, and refused a democratization after the end of the Cultural Revolution, as well as the notion of a set of rules governing interaction between people that were left without all solidarity and robbed of all spirituality; but not freed from their involvement in the Cultural Revolution, where victim and perpetrator were often combined in the same person.
This involvement and its immanent ambivalence is what Yang Shaobin showed us for many years, even when he refused to use the 'blood red paint' and his brushstrokes became more restful, as in the Blue Group from the last two years.

The red, 'incredibly beautiful paintings... the beauty of the repulsive,' as Karen Smith writes, are followed by works treating conflicts, violence, cold and hot wars in the twenty first century. Yang Shaobin makes use of already 'used' images from television and the Internet, pictures that we are subjected to daily. The artist consciously refuses the crea-

tion of image spaces and formally quotes the flat surface of newer media. The existential power and almost physically penetrating power of the red works is supplanted by an equally light and cool color: a painting that creates distance and almost forces us to engage in a deeper engagement.

And yet, an ambivalence remains that is typical of Yang Shaobin: the small-format painting 'Young Hero' shows the capped head of a young man before a light-blue-green map on which writing can be recognized. Despite diverse indications—the head covering seems to be a fez, as worn central Asia—the young hero is placed nowhere. Is it a shepherd or 'terrorist', does he live in Indonesia or in Afghanistan? He remains unlocated, like the artist.

Yang Shaobin, one of China's most prominent artists internationally, has been recognized by museums and state institutions at home, but his work has yet to be exhibited there.
A continuing injury? Is that why he paints the injured Kippenberger thirty years after the Four Modernizations and thirty years after the incident before the Berlin's SO36? Or is Yang Shaobin presenting positions from Western art in the Chinese context, opening them once more for discussion?

Martin Kippenberger, in diesen Tagen posthum in großen Ausstellungen gefeierter Künstler, verließ an einem regnerischen Berliner Morgen den heute legendären Club ‚SO36' (dessen Inhaber er damals war) und lief in eine veritable Falle. Punks, Freunde der szenebekannten ‚Ratten-Jenny', für die Kippenberger wohl eine Figur elitärer Arroganz abgab, lauerten ihm auf und schlugen ihn zusammen.
Kippenberger wurde ins städtische Urban-Krankenhaus eingeliefert und inszenierte ein formidables Bild, den ‚Dialog mit der Jugend': Des Künstlers Kopf, bandagiert und mit einer Haube versehen, diese unter dem Kinn mit einer Schleife zugebunden. Die Nase mit Pflastern und Verbänden verklebt, beschaut er prüfend die manikürten Fingernägel der linken Hand.

Später malt Kippenberger von diesem Zustand ein kleines Bild und dieses Motiv greift Yang Shaobin dreißig Jahre danach auf. Der Künstler stellt den Künstler in monochrom dunkelroten Farbtönen dar und ‚beruhigt' so das Motiv einerseits, während er es andererseits durch ein riesiges Format überhöht; diese hier sichtbar werdende Ambivalenz durchzieht Yang Shaobins gesamtes Werk seit den späten 1990er Jahren.
Er gibt der Arbeit den Titel ‚Strong Face (Kippenberger)' und schafft damit erstmals ein Bild eines Künstlers, der seine Verletzung sowie eine Reaktion darauf zeigt.

Freilich, Gewalt und die Auseinandersetzung mit Gewalt war und ist immer noch ein zentrales Motiv in den Gemälden und den Skulpturen des chinesischen Künstlers: In älteren Werken kämpft er mit seinem Bruder, mit sich selbst oder Künstlerfreunden wie dem gleichaltrigen Fang Lijun, mit dem er gemeinsam die Grundschule besuchte und der ihn später ermunterte Künstler zu werden.

Diese Bilder von kämpfenden Menschen reagieren auf die ‚neue Zeit' Chinas, die sich aus der post-maoistischen Politik der ‚Vier Modernisierungen' Ende der 1970er Jahre ergab. Die

,Modernisierungen' bezogen sich auf die Landwirtschaft, die Technik, die Wirtschaft, die Armee und verzichteten so auf eine Demokratisierung der Verhältnisse nach dem Ende der Kultur-revolution, ebenso wie auf die Idee eines Regelwerks zwischen den Menschen, die entsolidari-siert und jedweder spirituellen Haltung beraubt aus der Kulturrevolution entlassen wurden; nicht entlassen aber aus ihrer millionenfachen Verwicklung in die Kulturrevolution, einer Ver-strickung, die für die Chinesen immer Opfer- wie Täter-Rollen in einer Person bereithielt.
Diese Verstrickung und die ihr immanente Ambivalenz ist es, die uns Yang Shaobin viele Jahre zeigte, auch dort, wo er auf die ,blutrote Farbe' verzichtet und sein Pinselstrich ruhiger wird wie in der in den letzten zwei Jahren entstandenen ,blauen Gruppe'.

Den roten ,unglaublich schönen Gemälden ... der Schönheit des Abstoßenden', wie Karen Smith sie nennt, folgen Arbeiten, deren Sujets Konflikte, Gewalt, heiße wie kalte Kriege im 21. Jahrhundert sind. Yang Shaobin gebraucht hier schon ,benutzte' Bilder aus TV und Inter-net, also Bilder, denen wir täglich ausgesetzt sind. Der Künstler verzichtet bewusst auf die Schaffung von Bildräumen und zitiert hier formal die flache Oberfläche neuer Medien. Die existentielle Wucht und fast physisch durchdringende Kraft der roten Arbeiten weicht einer leichten wie kühlen Farbigkeit; eine Malerei, die Distanz schafft und uns gerade damit zur tieferen Auseinandersetzung zwingt.

Und doch bleibt die für Yang Shaobin typische Ambivalenz: das kleinformatige Gemälde ,Young Hero' zeigt den bemützten Kopf eines jungen Mannes vor einer lichtblau-grünen Landkarte, auf der Schriften zu sehen sind. Trotz diverser Hinweise – bei der Kopfbedeckung scheint es sich um den in Mittelasien üblichen Fez zu handeln – bewegt sich der junge Held im Niemandsland. Ist er Hirtenjunge oder ,Terrorist', lebt er in Indonesien oder in Afghanis-tan, er bleibt unverortet wie der Künstler.

Yang Shaobin, einer der international stark beachteten Künstler Chinas, wird ,zu Hause' von den Museen und staatlichen Institutionen zwar wahrgenommen, aber noch immer nicht ausgestellt.
Eine fortgesetzte Verletzung? Malt er deshalb, dreißig Jahre nach den ,Vier Modernisierungen' und dreißig Jahre nach dem Vorfall vor dem Berliner ,SO36' den ,verletzten Kippenberger'? Oder stellt Yang Shaobin künstlerische, dem Westen eigene Positionen im chinesischen Kon-text noch einmal zur Diskussion?

■ Martin Kippenberger, artista celebrado postumamente por estes dias com grandes expo-sições, em uma manhã chuvosa de Berlim deixou o hoje legendário clube "SO36" (cujo gerente era na época) e caiu em uma verdadeira armadilha. Punks, amigos de um sujeito conhecido na cena como "Ratten Jenny" (Jenny dos Ratões), para o qual Kippenberger pro-vavelmente era o retrato da elite arrogante, aguardaram em emboscada e o espancaram. Kippenberger foi internado no hospital municipal Urban-Krankenhaus e criou um quadro formidável, o "Diálogo com a juventude". A cabeça do artista foi enrolada e provida com uma toca, esta amarrada com um laço abaixo do queixo. O nariz coberto de curativos e band-aid, ele observa criticamente as unhas manicuradas da mão esquerda.

Mais tarde Kippenberger pinta um quadro pequeno desta situação e Yang Shaobin retoma o motivo trinta anos mais tarde. O artista apresenta o outro artista em tons de vermelho

escuro monocromático e desta maneira por um lado "acalma" o motivo, enquanto por outro o exacerba através de um formato enorme; a ambivalência que aqui se faz sentir, atravessa a obra inteira de Yang Shaobin desde o final dos anos noventa.

Ele denomina o trabalho "Strong Face (Kippenberger)" e assim cria pela primeira vez um retrato de um artista que mostra seus ferimentos e a reação que surtem.

É verdade que a violência e a confrontação com a violência continua sendo um motivo central dos quadros e das esculturas do artista chinês. Em obras mais antigas ele luta com o seu irmão, consigo mesmo ou com artistas amigos como Fang Lijun, da mesma idade, colega do primário que mais tarde o encorajou a ser artista.

Estes retratos de pessoas em luta são uma reação ao "novo tempo" da China, que resultou das políticas pós-maoístas das "Quatro modernizações" no final dos anos setenta. As "modernizações" referiram-se à agricultura, à tecnologia, à economia e às forças armadas e desta maneira renunciaram da democratização da sociedade depois do fim da revolução cultural, bem como da idéia de um sistema de regras entre as pessoas, que foram despedidas da revolução cultural privados da solidariedade e de toda e qualquer atitude espiritual, mas não despedidas dos embaraços milionários na revolução cultural, um enredo que para os chineses sempre reserva o papel de autor e vitima em uma só pessoa.

Este enredo e a ambivalência nele contido foi que Yang Shaobin nos mostrou durante muitos anos, mesmo quando abriu mão do "vermelho cor de sangue" e seu traçado de pincel ficau mais sereno, como nas obras do "grupo azul", criadas nos últimos dois anos.

Os quadros vermelhos, "incrivelmente lindos ... a beleza do repugnante" como Karen Smith descreveu, são seguidos de trabalhos que têm conflitos, violência, guerras quentes e frias do século XXI como motivo. Neste caso Yang Shaobin utiliza imagens "usadas" da TV e da Internet, que dizer imagens às quais somos expostos todos os dias. Conscientemente o artista renuncia à criação de profundidades e cita formalmente a superfície plana da mídia nova. O impacto existencial e a força quase fisicamente penetrante dos trabalhos vermelhos cede o espaço para uma cromática leve e neutra, uma pintura que gera distancia e justamente por este caminho nos força a uma confrontação mais profunda.

Mesmo assim permanece a ambivalência típica de Yang Shaobin: O quadro de formato pequeno "Young Hero" mostra a cabeça de um homem jovem com barrete na frente de um mapa em tonalidades de azul claro e verde, sobre o qual podemos ver textos. Apesar de vários indícios – o barrete parece ser um tarbush, geralmente usado no oriente médio – o jovem herói encontra-se no "nowhere land". Será ele um pastor de gado ou "terrorista", vive ele na Indonésia no Afeganistão, ele continua sem localização como o artista.

Yang Shaobin, um dos artistas chineses internacionalmente mais conceituados, "em casa" já é reconhecido pelos museus e as instituições estatais, porém ainda não foi agraciado com uma exposição.

Seria uma ferida aberta? Seria por este motivo que pinta, trinta anos depois das "quatro modernizações" e trinta anos depois do incidente em frente do "SO36" em Berlim, o Kippenberger ferido? Ou será que Yang Shaobin apresenta posições artísticas, próprias do ocidente, para novo debate no contexto chinês?

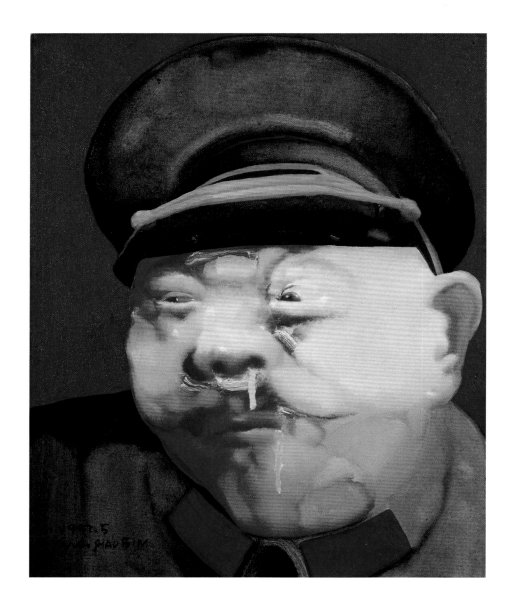

Untitled, 1997
Oil on canvas, 41 x 33 cm

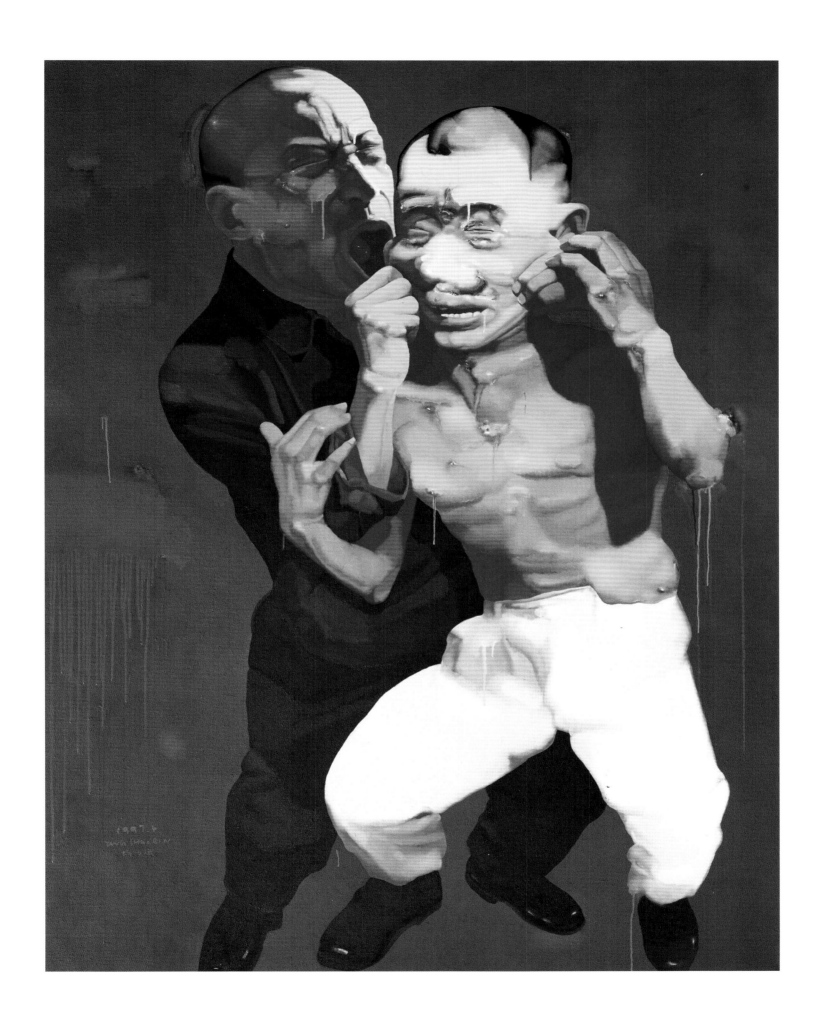

Untitled, 1996
Oil on canvas, 220 x 180 cm

Untitled, 2006
Oil on canvas, 260 x 180 cm

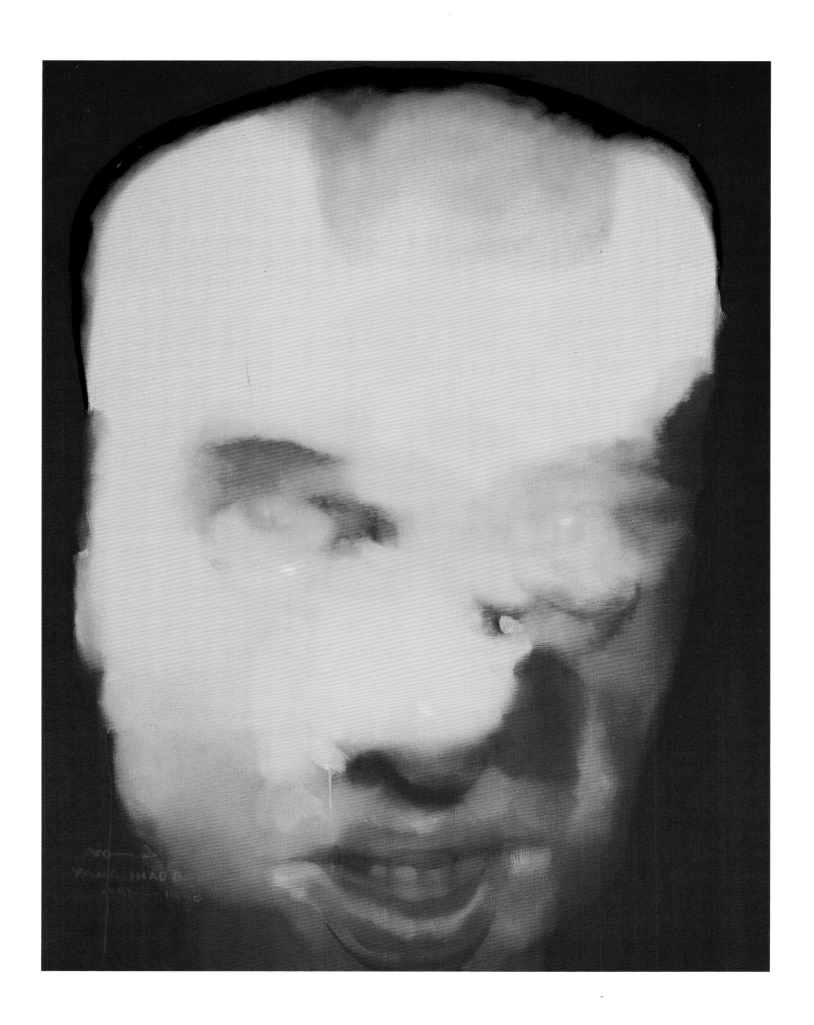

Portrait (No. 2), 1997-1998
Oil on canvas, 230 x 180 cm

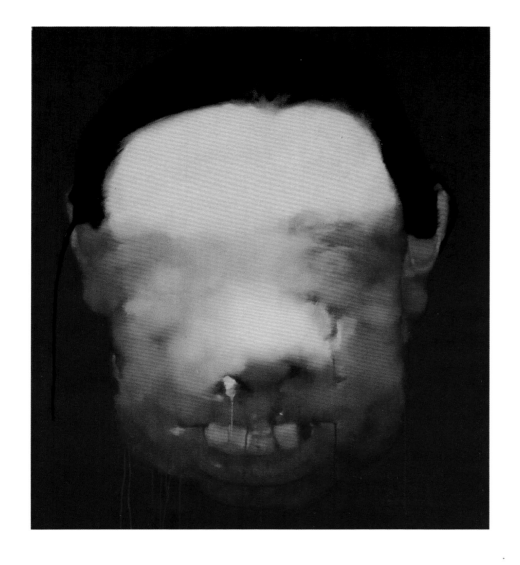

2000-8 No. 16, 2000
Oil on canvas, 160 x 140 cm

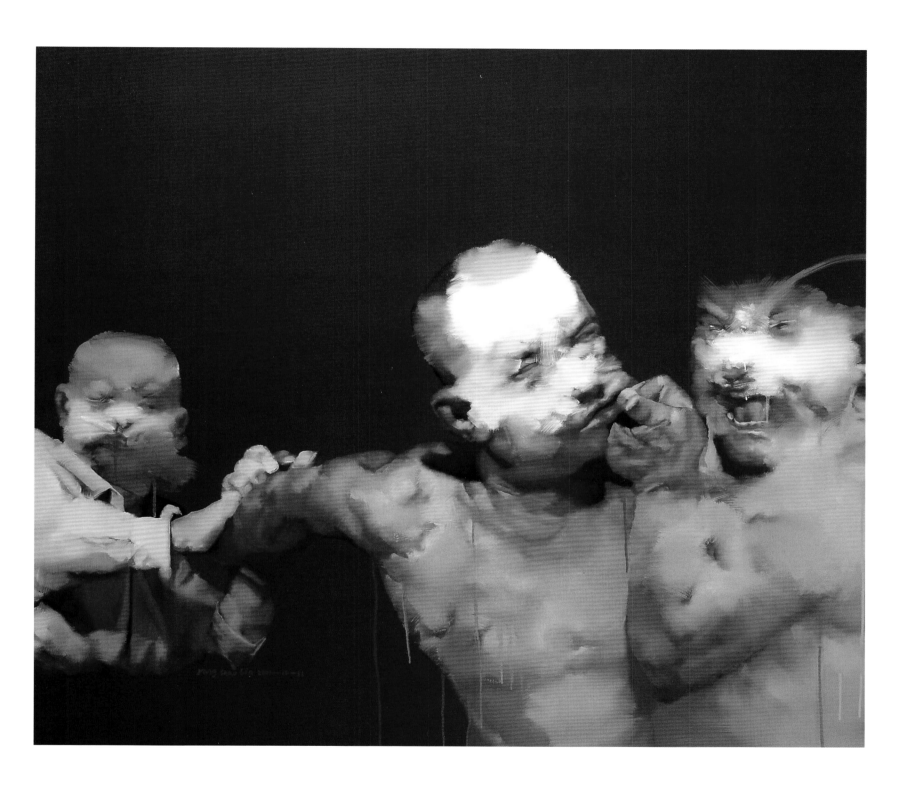

2001-10-31, 2001
Oil on canvas, 140 x 160 cm

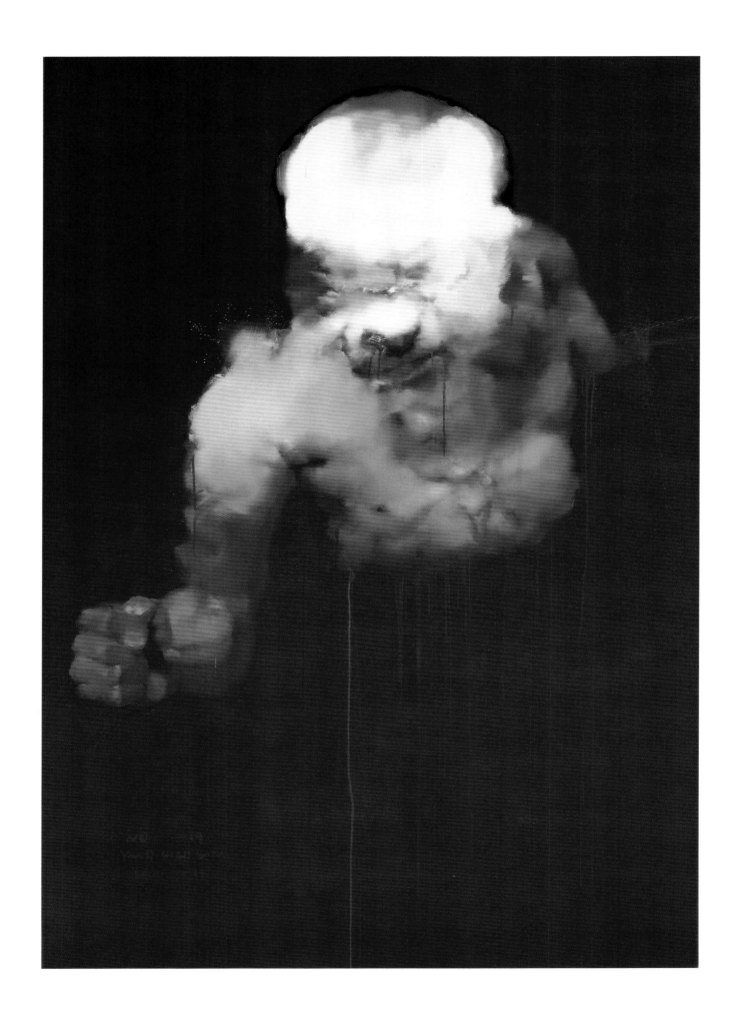

2000-10 No. 19, 2000
Oil on canvas, 260 x 180 cm

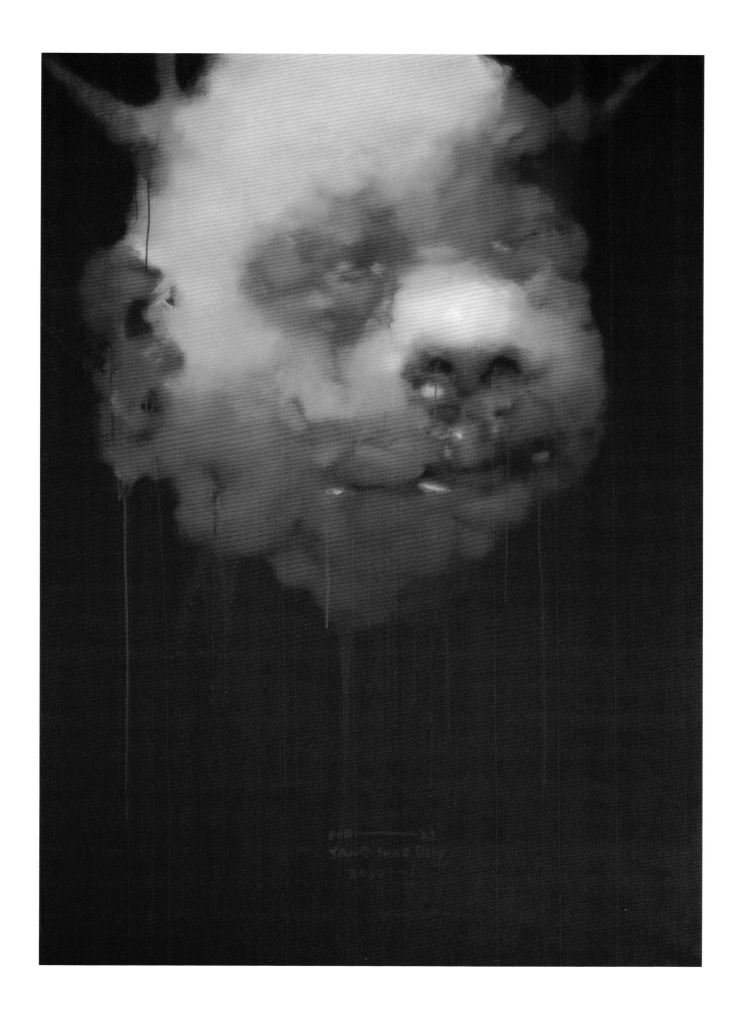

2000-12, No. 21, 2000
Oil on canvas, 260 x 180 cm

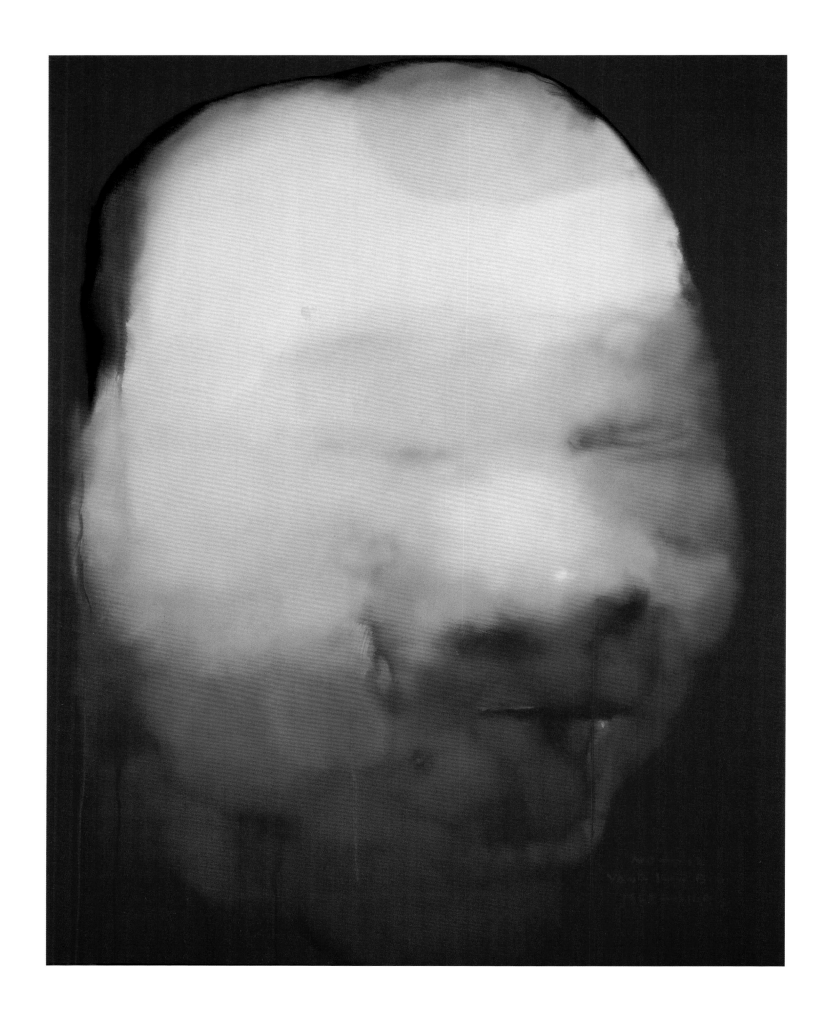

Untitled, 1998-1999
Oil on canvas, 230 x 180 cm

20

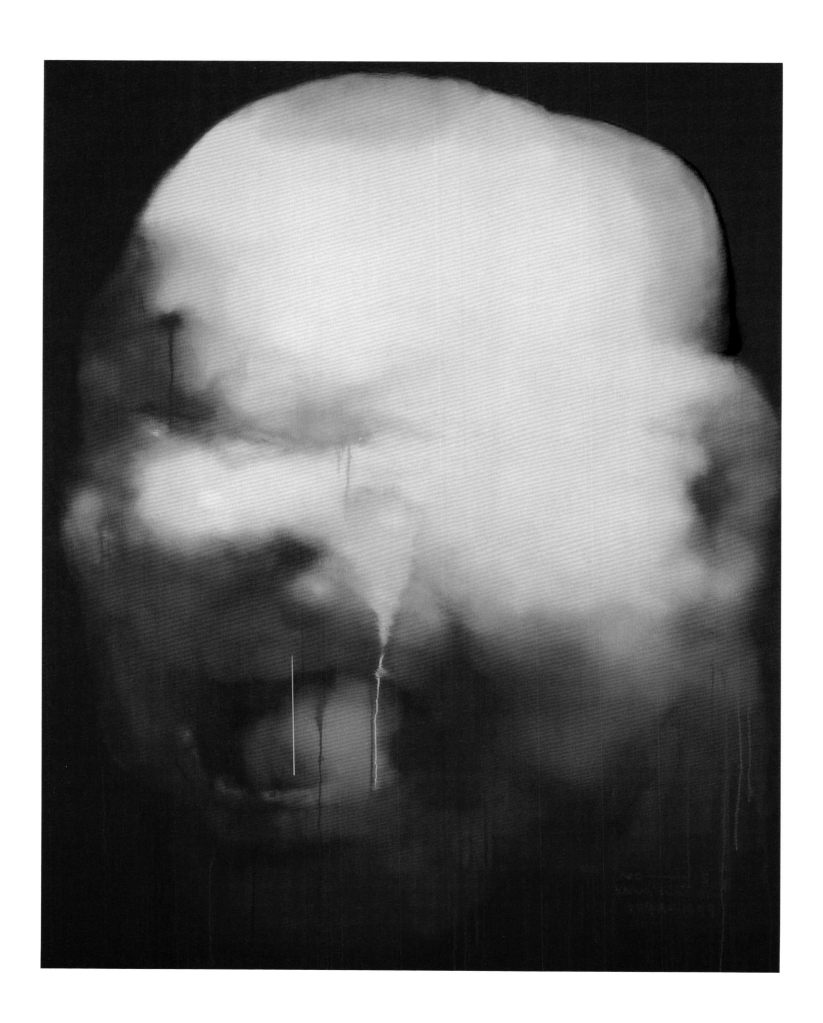

Untitled, 1998-1999
Oil on canvas, 230 x 180 cm

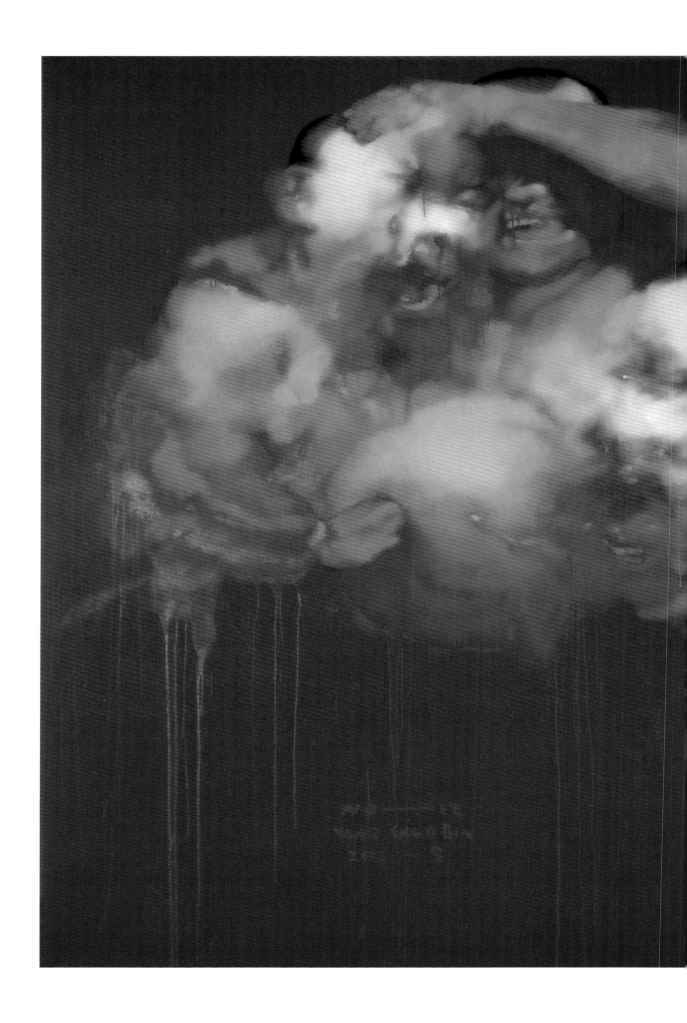

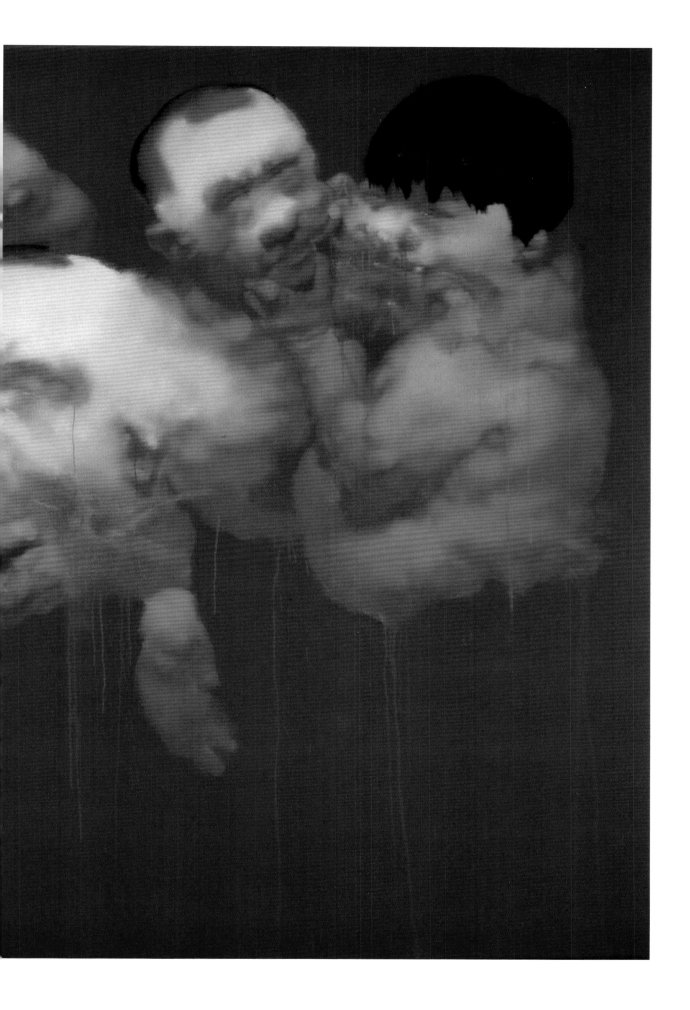

Untitled, 2000
Oil on canvas, 2 panels, each 230 x 180 cm

23

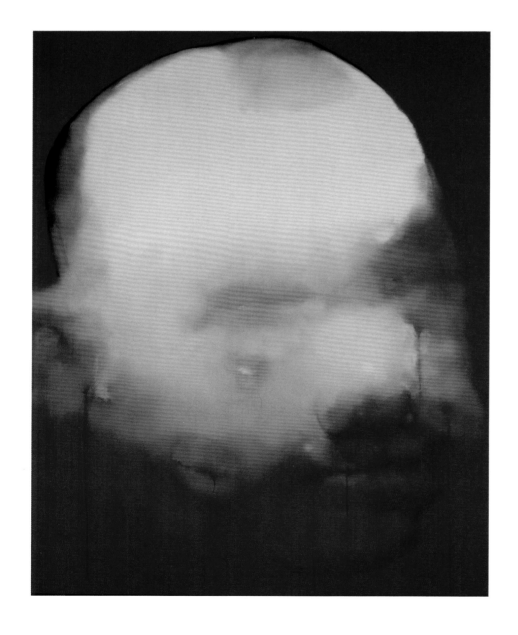

Untitled, 1998-1999
Oil on canvas, 230 x 180 cm

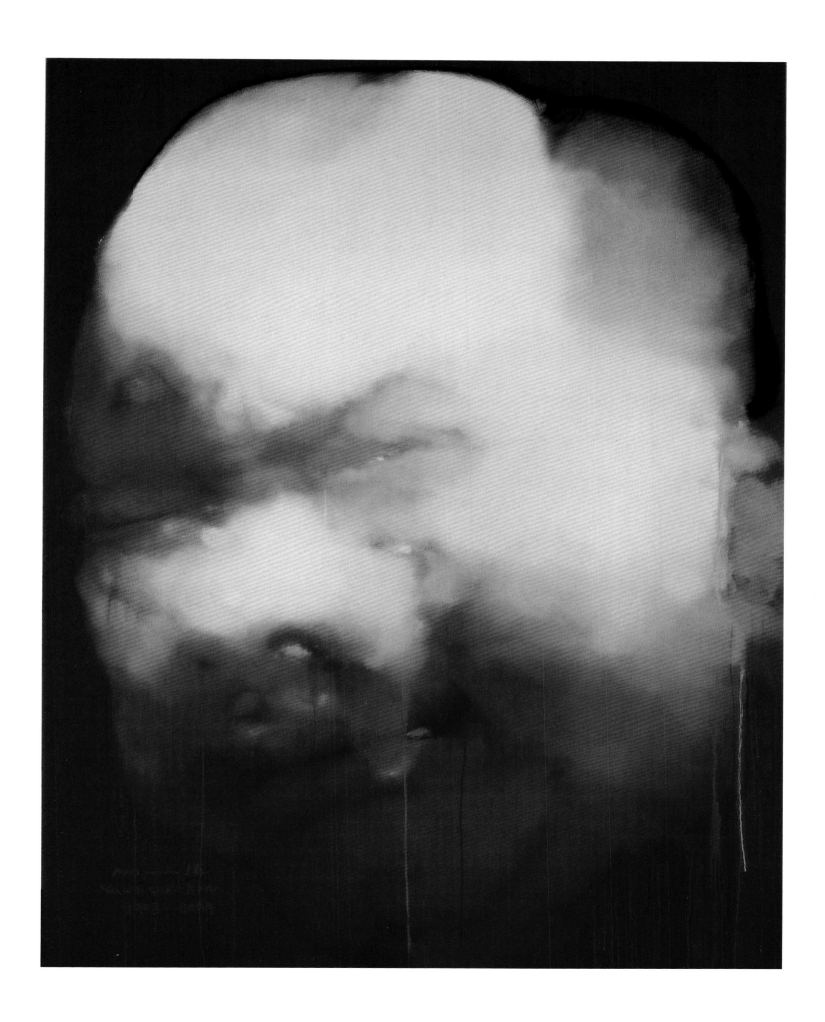

Untitled, 1998-1999
Oil on canvas, 230 x 180 cm

25

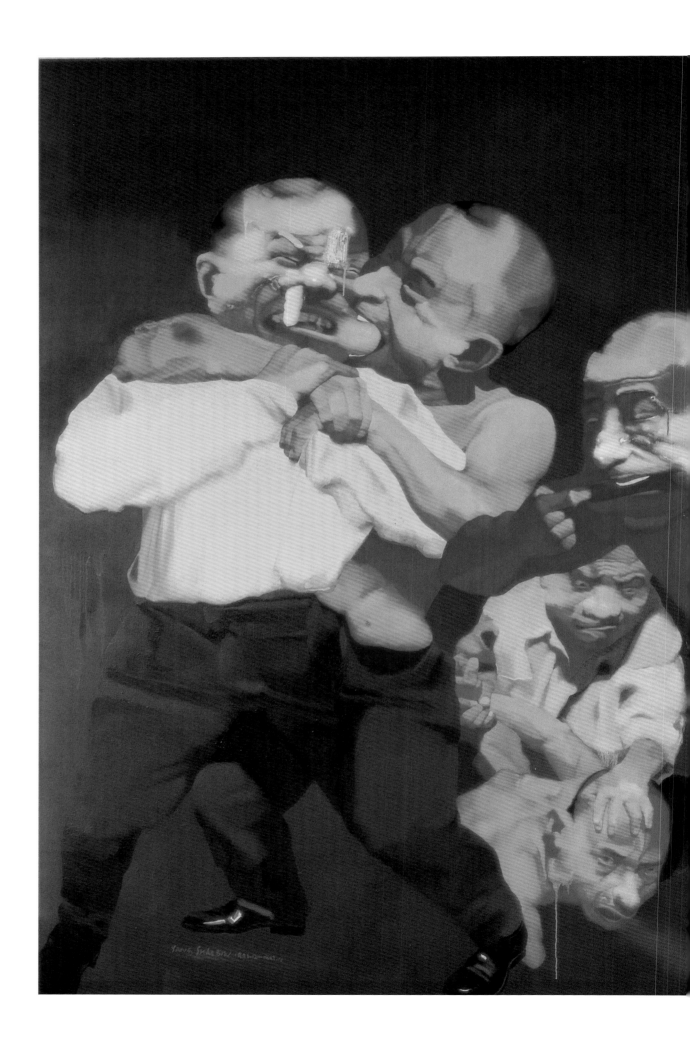

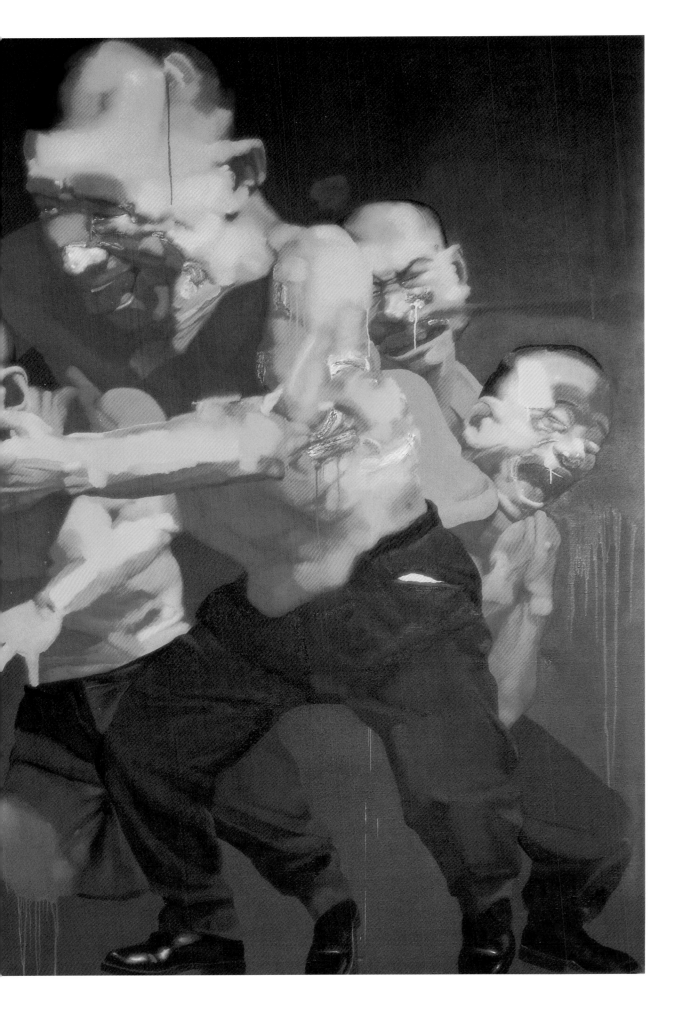

Untitled, 1996-1997
Oil on canvas, 260 x 360 cm

My ideal in painting would have been something very calm, canvases where feelings existed. I was tired of Cynicism. It was like digging for ideas, in order to please people. Moreover, it just wasn't me, not my character. It felt like I was playing a role and that bothered me.

Was den Bildinhalt betrifft hatte ich eine Idealvorstellung: ich wollte in ausgeglichener Verfassung malen, im Bildinhalt sollte sich eine Gemütsstimmung erkennen lassen. Ich fand es sehr anstrengend Zynischen Realismus zu malen. Man versucht mit allen erdenklichen Mitteln, Leute zum Lachen zu bewegen. Und dazu kommt noch, dass ich ursprünglich gar nicht übe solche Charaktereigenschaften verfüge. Meine Gemütslage lässt das nicht zu, es war als ob ich Theater spielte, es machte mich wahnsinnig.

Quanto ao conteúdo dos quadros tive um ideal. Eu queria pintar em um estado de espírito equilibrado, de forma que o conteúdo deixe transparecer o meu astral. Achei muito cansativo pintar Realismo Cínico. É tentar fazer as pessoas rir a qualquer custo. Além do mais, não disponho de tais qualidades. O meu estado de espírito não permite, foi como fazer teatro, me deixou louco.

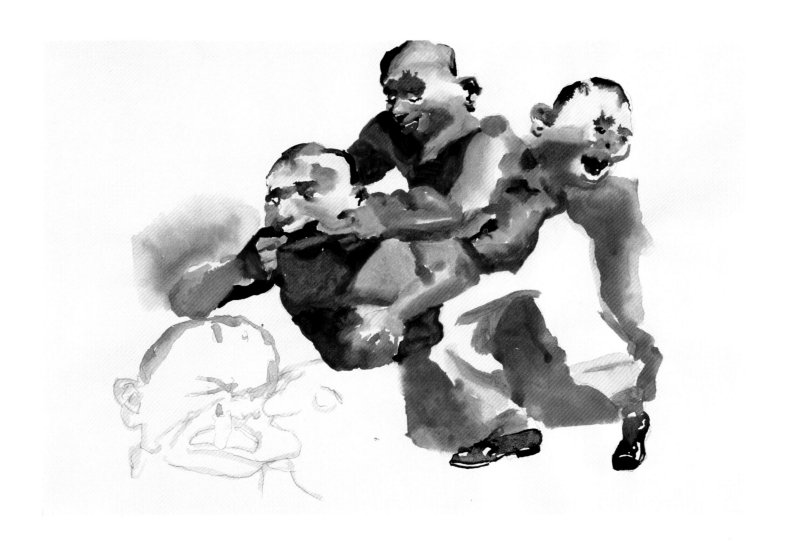

Untitled, 2000
Watercolour on paper, 36 x 47 cm

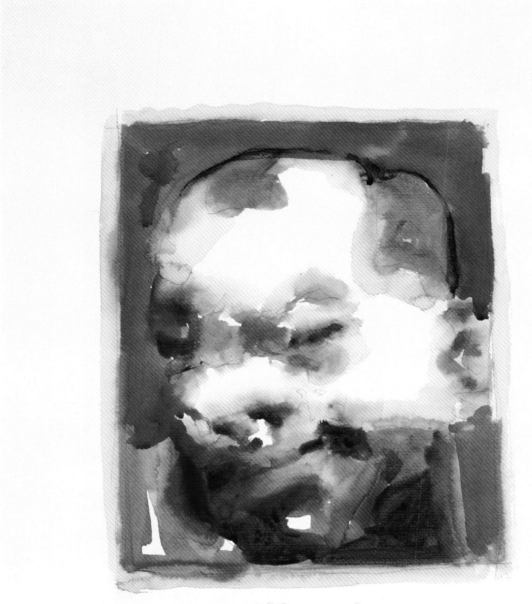

Untitled, 1998
Watercolour on paper, 47 x 36 cm

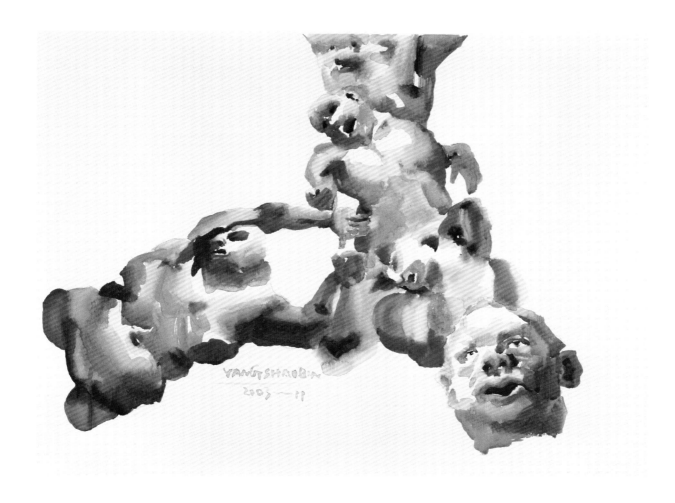

Untitled, 2003
Watercolour on paper, 36 x 47 cm

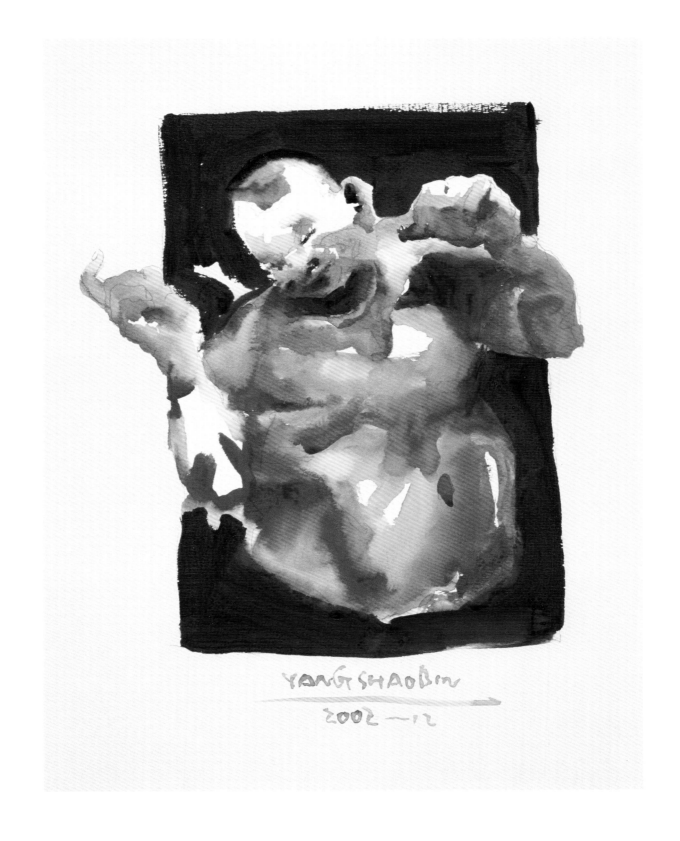

Untitled, 2002
Watercolour on paper, 47 x 36 cm

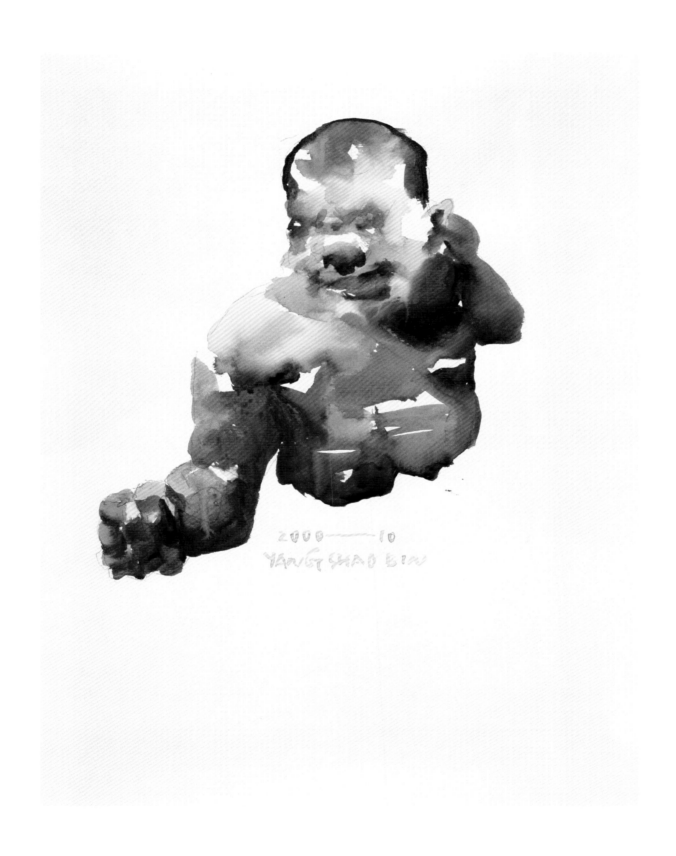

Untitled, 2000
Watercolour on paper, 47 x 36 cm

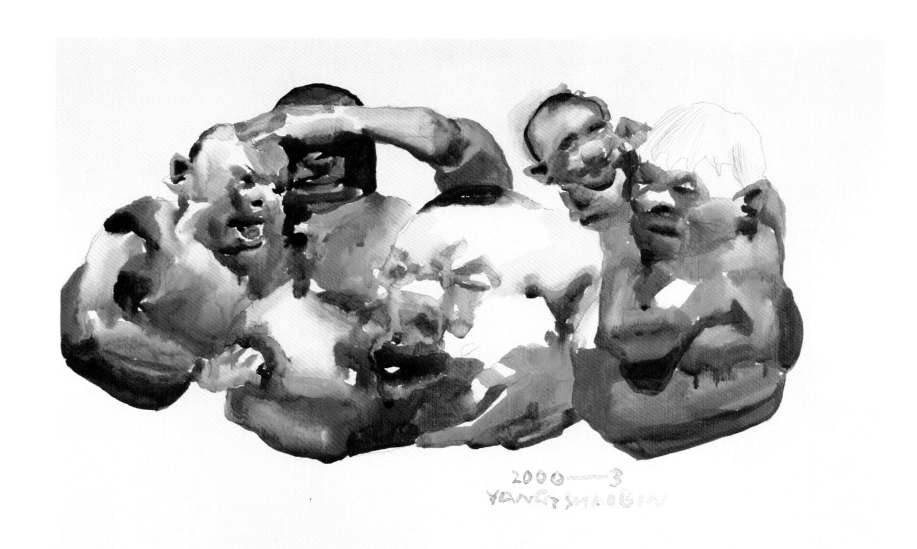

Untitled, 2000
Watercolour on paper, 47 x 36 cm

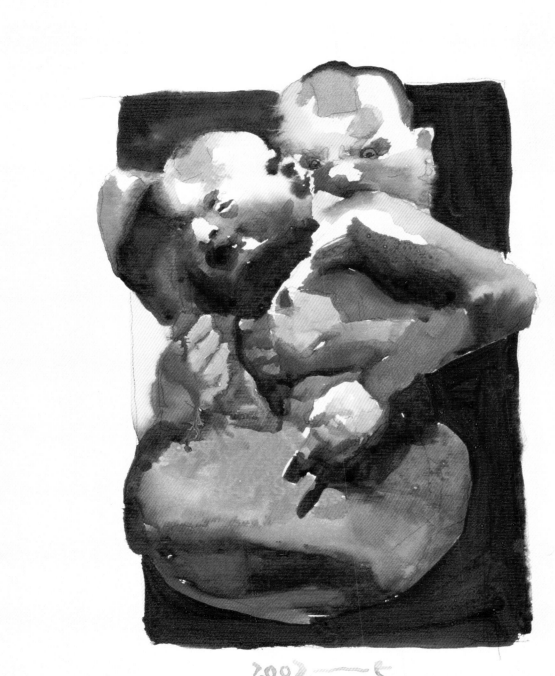

Untitled, 2002
Watercolour on paper, 47 x 36 cm

35

 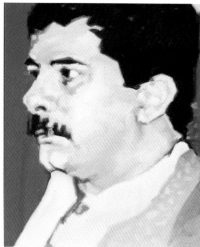 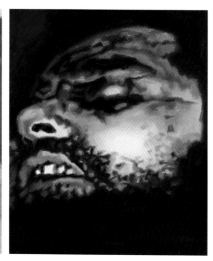

Who, 2006
Oil on canvas, 4 parts, each 53 x 42 cm

36

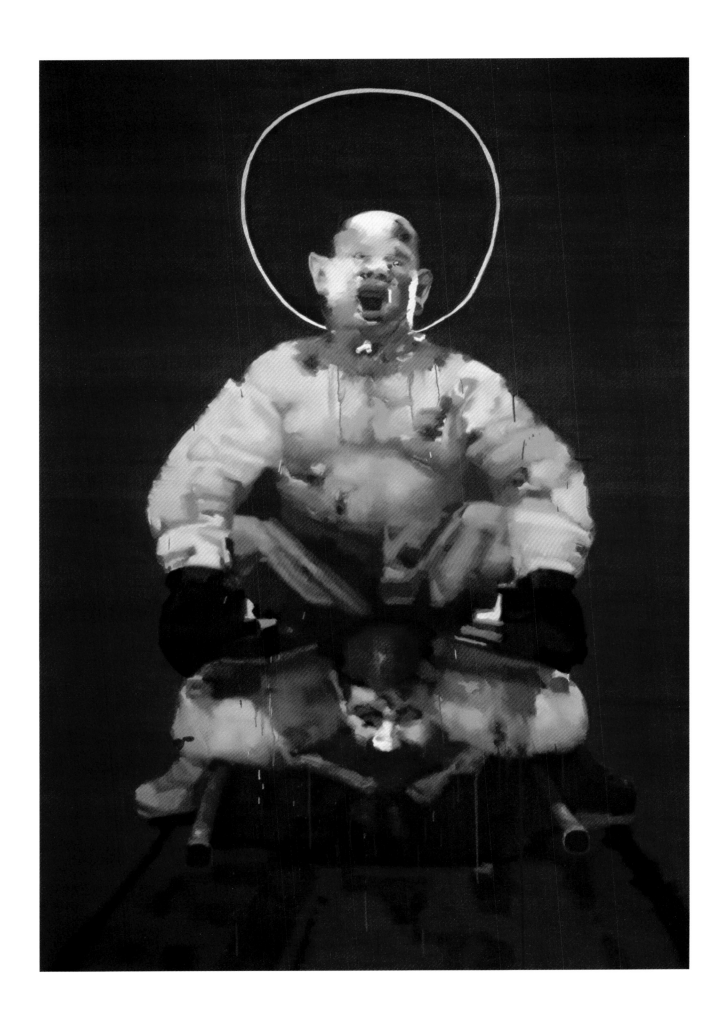

Scandal – Killing Rope (Cord of Life), 2006
Oil on canvas, 260 x 180 cm

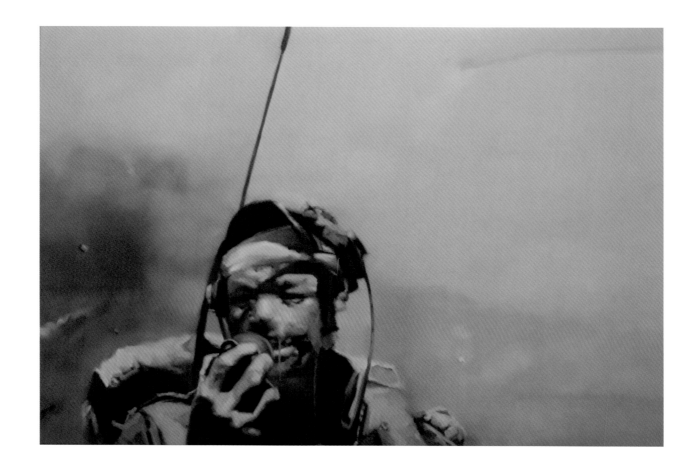

Hero Wang Cheng, 2005
Oil on canvas, 115 x 164 cm

Untitled 6, 2006
Oil on canvas, 120 x 150 cm

Too Full to Do Silly Things, 2009
Oil on canvas, 102 x 180 cm

Shoot a Bird, 2009
Oil on canvas, 260 x 180 cm

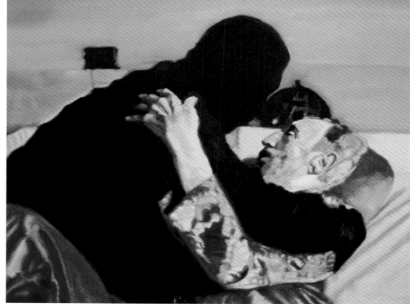

Fidel Castro, 2006
Oil on canvas, 4 parts, each 74 x 94 cm

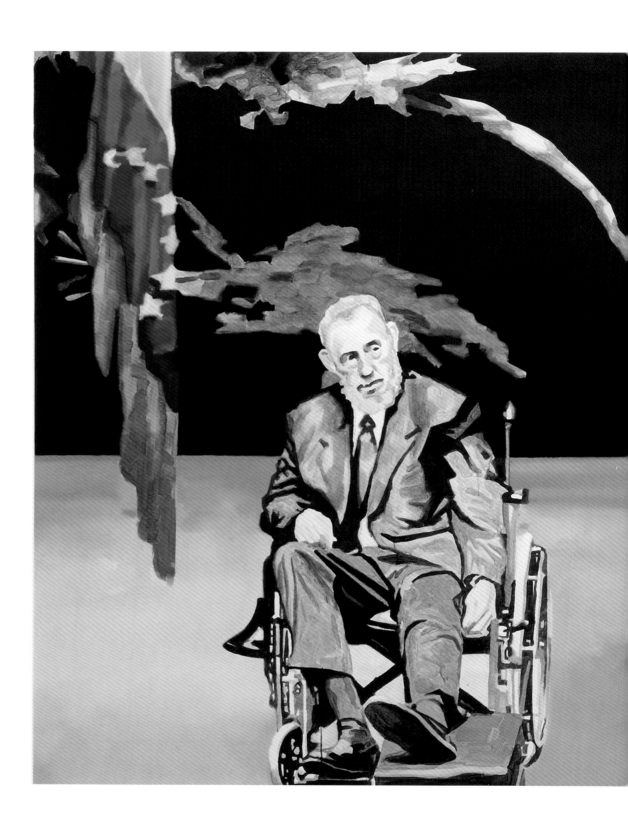

My Left Leg, 2008
Oil on canvas, 194 x 357 cm

In the beginning, there was a feeling of anger, of aggression, and at the same time of powerlessness: the red body battles. There was no overarching concept. Then there was the time when I sat in front of the television and collected material for new works. The trigger for this series was September 11, 2001. World politics have thus also become a personal threat.

Am Anfang war da das Gefühl von Wut, von Aggression und gleichzeitig von Ohnmacht – das sind die roten Körperschlachten. Da gab es kein übergeordnetes Konzept. Dann kam eine Zeit, in der ich mit dem Fotoapparat vor dem Fernseher saß und Material für neue Arbeiten sammelte. Auslöser für diese Serie war der 11. September 2001. Weltpolitik ist dadurch auch zur persönlichen Bedrohung geworden.

No inicio era o sentimento de rancor, de agressão e paralelamente o sentimento de impotência – são as batalhas corporais em vermelho. Não existia um conceito superior. Depois veio uma época na qual fiquei com a máquina fotográfica em frente da TV e colecionei material para novos trabalhos. O ponto de partida para esta série foi o 11 de setembro de 2001. Em função disto, a política mundial tornou-se inclusive ameaça pessoal.

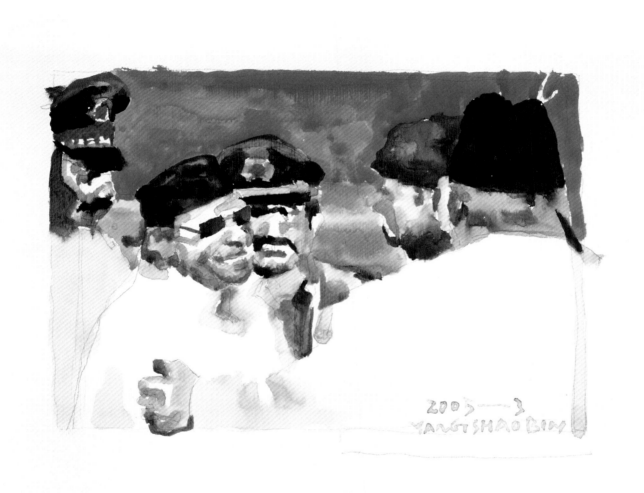

Untitled, 2005
Watercolour on paper, 36 x 47 cm

Untitled, 2005
Watercolour on paper, 36 x 47 cm

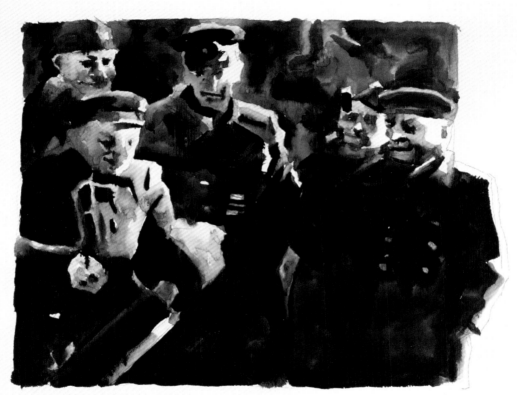

Untitled, 2005
Watercolour on paper, 36 x 47 cm

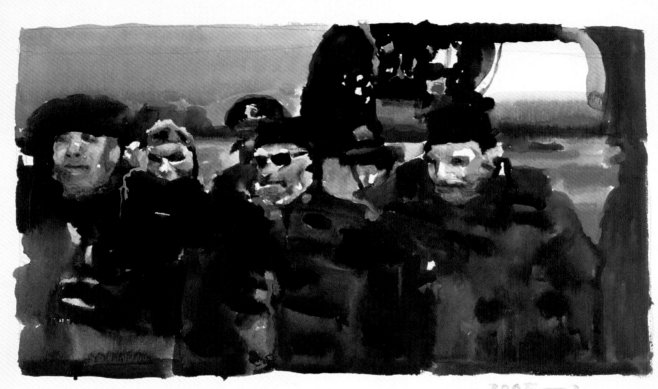

Untitled, 2005
Watercolour on paper, 36 x 47 cm

Untitled, 2005
Watercolour on paper, 36 x 47 cm

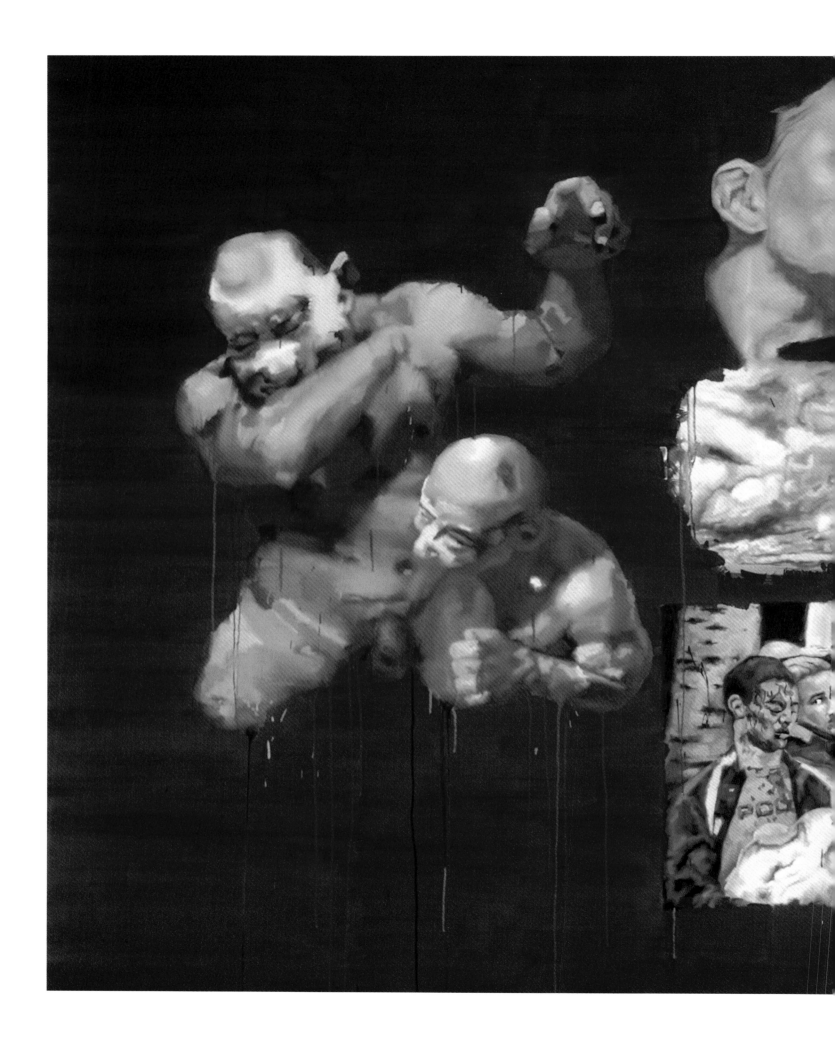

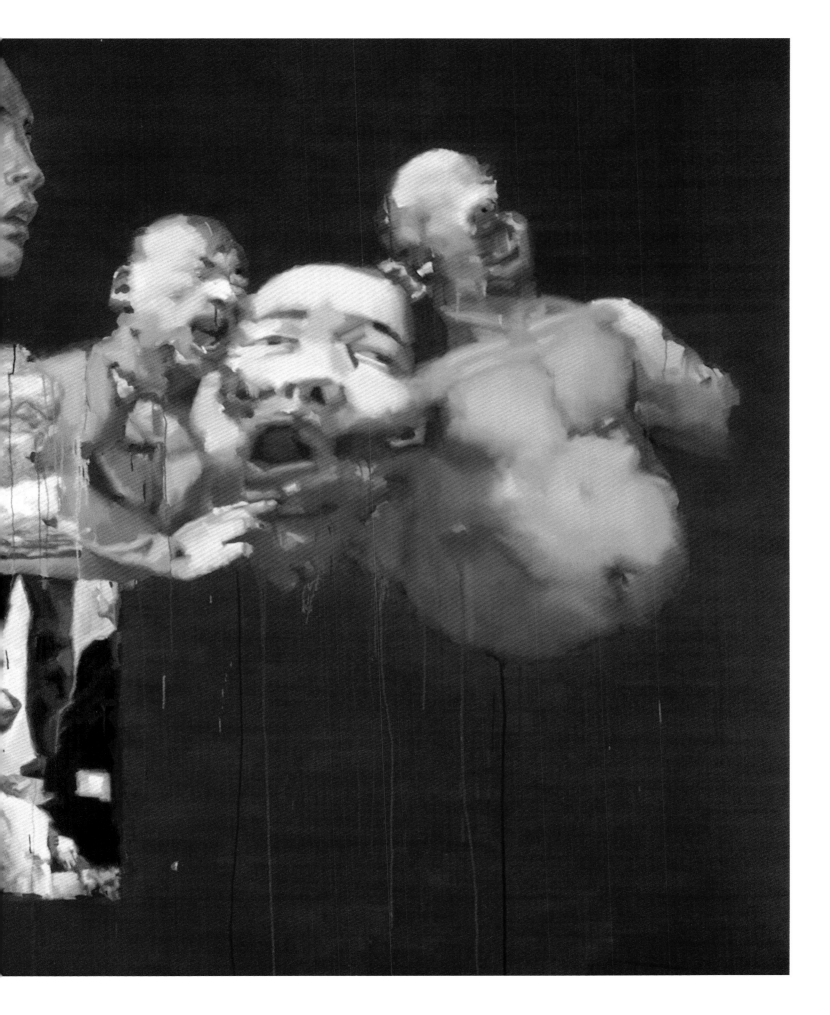

New Cross, 2006
Oil on canvas, 210 x 350 cm

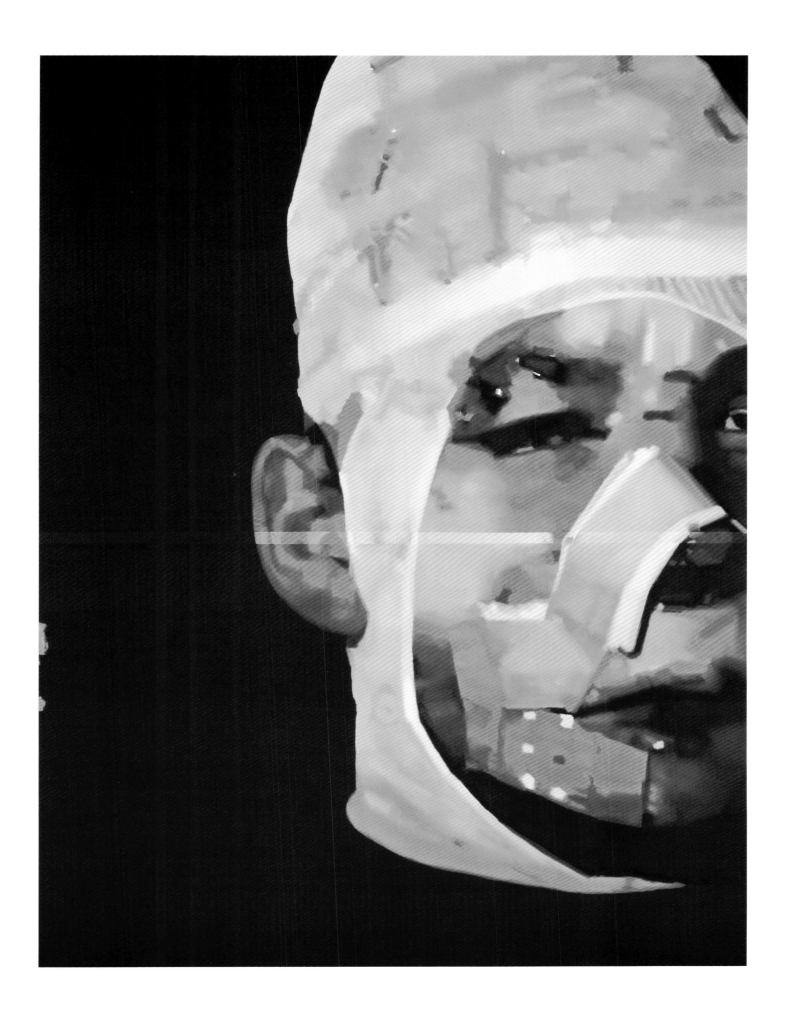

Strong Face (Martin Kippenberger), 2009
Oil on canvas, 280 x 210 cm

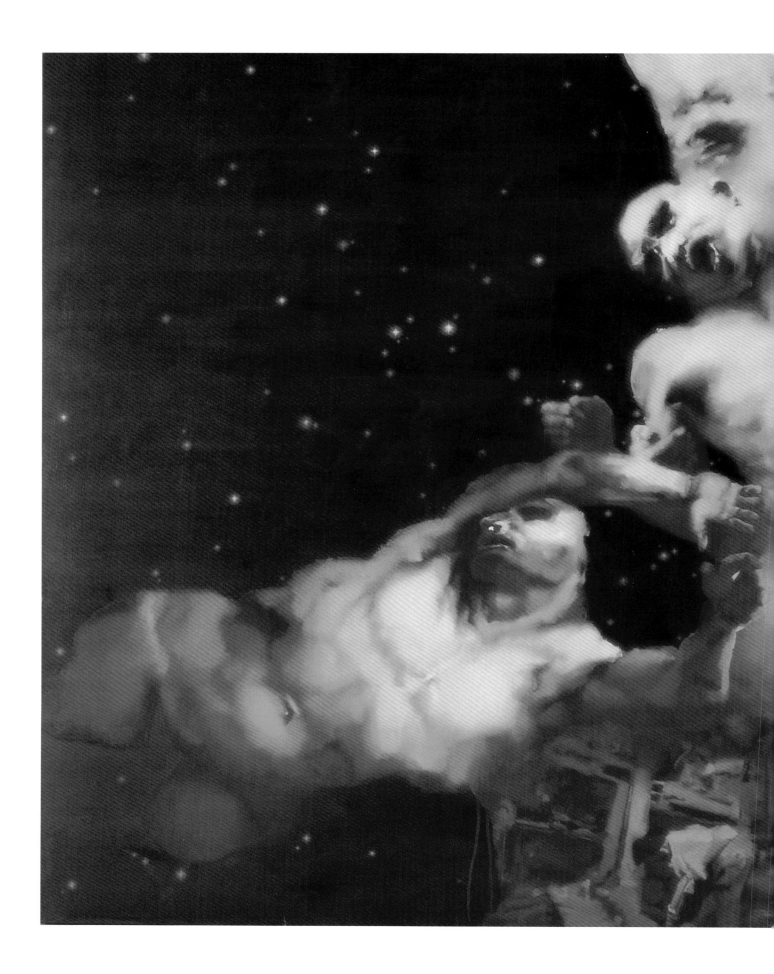

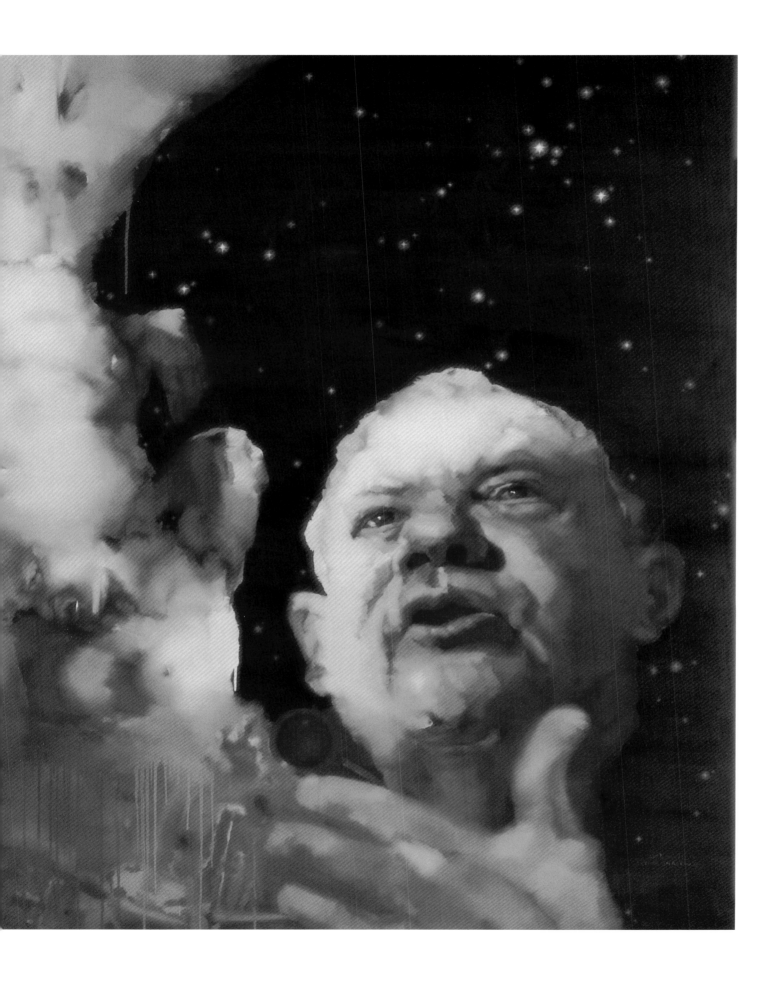

Trinity, 2003
Oil on canvas, 210 x 350 cm

TEREZA DE ARRUDA

FIRST STEPS – LAST WORDS
ERSTE SCHRITTE – LETZTE WORTE
PRIMEIROS PASSOS – ÚLTIMAS PALAVRAS

Museu de Arte de São Paulo Assis Chateaubriand is presenting the exhibition 'First Steps – Last Words', which was designed exclusively for this museum as Yang Shaobin's first exhibition in Latin America. The focus is an overview of his work spanning the period from 1996 to 2009.

China went through a long period of international projection and recognition in the last decades, culminating in its hosting the 2008 Olympic Games in Beijing. The political system has not changed, but the living standards of the Chinese people have risen to an extent unprecedented in their own context—until the outbreak of the current global economic crisis. This entire scenario is viewed and reviewed by contemporary Chinese art through the work of artists such as Yang Shaobin. A keen observer of his surroundings and the globalized world context, Yang Shaobin has become a witness of his times, leaving unpredictable marks.

Yang Shaobin was born in 1963, and was still living in the city of Handan, in Hebei province, in 1989. It was not until 1991 that he moved to Beijing after leaving the porcelain factory where he had worked as a designer for seven years. After a while he moved to the legendary Yuanmingyuan, the first artists' village. This experience gave an incisive impulse to his artistic career, but Yang remained a self-taught artist after his unsuccessful attempts to enroll at the Central Academy of Fine Arts in Beijing.

His art training arose from his own instinct and perception through the report on the metamorphosis underway, dealing as social and political manifesto. His early work from this period shows groups of uniformed police, their faces melting into broad smiles, dispelling the myth of the uniform as a symbol of power in a system that was changing and being de-mystified. This representation may also be seen as an irony of destiny, since one of Yang Shaobin's first jobs was in the police force, which gave him the experience of behaving like a bad guy monopolizing power. Through his new role as a visual artist he was able to reverse roles, visualize his own history and free himself from past habits. This diversity is only possible in a system undergoing transition, which provides an outlet for the existence of individuality after a series of disappointments with real life, as if a 'realism of disillusionment' were emerging in his work.[1]

His painting quickly gained recognition and an artistic career developed at the same rapid pace as the dynamic growth of China itself in the 1990s. In 1993 Yang Shaobin started to show internationally and by 1999 his work was presented at the Venice Biennial curated by Harald Szeemann alongside Sigmar Polke in strong correspondence.

Yang Shaobin quickly matured and condensed artistic trends in both conceptual and aesthetic aspects of his work. Due to personal issues and his globalized experience, he moved on from the prevailing sarcasm to deal with contemporary violence: as if the world around him were undergoing an unprecedented personification. The same policemen of his previous works are no longer wearing forced smiles indicating mockery. Their outlines no longer have clearly defined features or the expression of irony, which has given way to reproduction of body mass without identity of its own but has animal-like characteristics.

Unrelenting, the artist created a series of paintings in a deep red, reminiscent of the color of the Russian Revolution and all socialist revolutions, including the Chinese Cultural Revolution.

As an artist, he has been profoundly affected by innumerable political developments. He no longer focuses on the microcosm of his existence but looks at the global macrocosm. In this period he was increasingly relating to Western contemporary art, finding in it key figures advocating the same artistic ideology. Yang Shaobin believes in cultural symbiosis: 'My view is that, in art, collaboration between cultures is just as important in the trading relations. It is a chain of mutual dependencies, in which every link is contained in the other.'[II]

Focusing on the history of contemporary art, Yang Shaobin finds many observers attuned to the same concerns, anxieties, using similar representations. The deformed figures of Francis Bacon, who led a life of endless battles on both personal and political levels, spoke of fragmentation of human beings by banal or everyday violence. Hermann Nitsch's blood-bathed performances and the dissection of animals confronted viewers

I

The term 'realism of disillusionment' was used by Karl Mannheim for an intellectual trend that emerged after the First World War which has modern society seeking support in the collective as an escape route. *Helmut Letben: Der Kult der Distanz und seine anthropologische Begründung.* In: *Harmut Eggert. Faszination des Organischen: Konjunkturen einer Kategorie der Moderne.* Munich, Iudicium, 1995, p. 176.

II

In an interview for a publication on the Mahjong exhibition. Bernhard Fibicher and Matthias Frehner (Eds.): *Mahjong. Chinesische Gegenwartskunst aus der Sammlung Sigg.* Ostfildern-Ruit, Hatje Cantz, 2005, p. 53.

with death and other symbologies that were seen as taboo in everyday life. This subject brings me to the Mexican representation at the current Venice Biennial focused on the work of Teresa Margolles, whose fabrics are dyed with blood and mud from sites in Mexico where bodies of victims of urban violence were found. Water flowing from these soaked fabrics is used to clean the floor of the building, Palazzo Rota Ivancich, in which the work is being shown.

Are the impacts and brutal aspects of the aberrations and contradictions of modern life attenuated by the effect of repetition? Or would repetition not be the only effective artifice in the battle against being forgotten? Countering absurd moralistic interventions such as denying that the Holocaust took place? Civilization needs vociferous figures acting across disciplines and transparently, denouncing violence, in the visual arts, cinema or literature, in order to gain critical mass by reaching an increasingly broader audience through their testimony. Hannah Arendt, for one, spent her life trying to warn against the monstrosities of the Holocaust.[III]

Yang Shaobin's 'red' series bears striking witness to his times and has lost none of its actuality and vitality, so it has been a key motif in his work for years, although alternating with other series of different colors. It has become his strongest hallmark, recognized and respected internationally. The liquidity of the representation of bodies, the duality between the warmth of the deep red in conflict with cool white surfaces on which blood no longer flows, and the existence of pinkish masses through the conjunction of the two effects initially prompts repugnance. Taking bodies apart reveals human frailty. But more meticulous appreciation of his work shows striking and painful expressions, and seductive torsos full of vitality. Recent works such as 'Who Defaced Me?' and 'Profound Birthmark' include contemporary ornamental items such as military aircraft in the latter, which appear to be tattooed on the skin of an individual oscillating between the scale of a Greek god and a human being mutilated by war.

War scenes or battlefields have become commonplace in cinema and television, and a constant feature of daily newscasts too, unfortunately. War is an aesthetic media spectacle. Especially after the September 11 terrorist attack, which immediately led to the war in Iraq and a broad participative discussion internationally, there was pressure on many countries to take positions. Some 2,000 American journalists, we are told, covered the war in Iraq, and almost 500 of them were on the ground before the conflict started in order to convey viewers the sensation of watching events live as they developed.[IV] Amid this political battle, Yang Shaobin feels the need to express himself. He then revisited the history of war in his country, such as the brutal Japanese occupation of 1931-1945. Violence generates violence, and Japanese forces were not expelled until atom bombs were dropped on Hiroshima and Nagasaki in August 1945. His images of war motifs are often taken from the media, since the latter are implacably simultaneous and authentic. His paintings revisit this scenario with contrast between light and dark, abstract and figurative. These trends eventually merge into a single work and the unclear nature of the motif represented may be seen as a result of the dynamically paced actions of the protagonists involved in this battle. Subtle use of different colors with a slight predominance of black conveys the strain experienced in war.

Yang Shaobin perhaps felt this tension and a taste of heroism when he wore his police uniform in the past. Whatever his own experience, his socialist education certainly featured gripping images of everyday heroes in party propaganda seen through the eyes of a naive child. These everyday heroes were everywhere in China, in every walk of life. As

III
'When I think back to the last two decades since the end of the last war, I have the feeling that this moral issue has lain dormant because it was concealed by something about which it is indeed much more difficult to speak and with which it is almost impossible to come to terms—the horror itself in its naked monstrosity. When we were first confronted with it, it seemed, not only to me but to many others, to transcend all moral categories as it certainly exploded all juridical standards. (...) I used to say, this is something which should never have happened, for men will be unable to punish it or forgive it.' Hannah Arendt: 'Some Questions of Moral Philosophy.' *Social Research*, Winter 1994.

IV
Source: Florian Rötzer. Der Krieg als ästhetisches Medienspektakel. In: *Kunst und Krieg. Medienbrüche und epochale Veränderungen.* Kunstforum International. Vol. 8 165, June-July 2003, p. 53.

if in a silent tribute to these people, Yang Shaobin did a long series dedicated to coal miners, their features disguised by arduous marks of spending days 800 meters underground show worn smiles—spontaneous or forced—which undoubtedly raises the question of their existence and the national pride rooted in party identity.

The question of the State is also a key feature of Yang's work. His gaze falls on different angles, including his look at the activities of the 'overlords'. This gave rise to a series of paintings of heads of state. Fidel Castro, honored in a series taken from press images of his latest appearances in public, certainly has striking presence. The fragility of his advanced age raises the question of the myth of his unending power. The natural deformation of his aging body may perhaps somehow parallel the deformation of the myth of his role and his system.[V] Yang Shaobin is a keen observer of this context, since China and Cuba have the same political system. This familiarity prompts his interest in finding other shared manifestations, which would have to be analyzed meticulously given the rapid pace of sociopolitical developments. Its echo will be felt in both West and East.

Like war reporters, Yang Shaobin will continue to watch and report events undaunted by the psychic or physical marks left, or by mutilations. Indeed one of the images and episodes that most caught his attention in recent times was the attack on artist Martin Kippenberger in 1979. At the time, Kippenberger, one of the owners of the legendary SO36 club in Berlin, was attacked by a group of punks. Yang showed his painting 'Strong Face (Martin Kippenberger)' as one of the key works at his last solo show in Berlin. In this portrait, Kippenberger's head and face are covered in band-aids and some wounds are still visible. The entire composition oscillates between shades of red, black and white focusing on the intensity of the moment. The face is off-center on the canvas, with its extreme right remaining incognito. Thin washed-out brushwork in different shades of red refer to the blood that flowed in this incident.

Wherever he goes, Yang Shaobin strives to understand the local context and in his own way take new steps toward East-West dialogue. 'First Steps – Last Words' is his first solo exhibition in Latin America. This new step will lay a new pathway!

◾Das Museu de Arte de São Paulo Assis Chateaubriand präsentiert die Ausstellung ‚Erste Schritte – Letzte Worte', die exklusiv für dieses Museum als Yang Shaobins erste Ausstellung in Lateinamerika konzipiert wurde. Die Ausstellung bietet einen Überblick über seine Arbeit von 1996 bis 2009.

China hat in den letzten Jahrzehnten eine lange Periode internationaler Projektion und Anerkennung erlebt, die ihren Höhepunkt fand, als das Land 2008 die Olympischen Spiele in Beijing ausrichtete. Das politische System hat sich nicht verändert, aber der Lebensstandard der Chinesen ist auf bis dahin unerhörte Weise angestiegen – bis zum Ausbruch der aktuellen globalen Wirtschaftskrise. Dieses ganze Szenario wird von der zeitgenössischen chinesischen Kunst betrachtet und kommentiert – durch die Arbeit von Künstlern wie Yang Shaobin. Als genauer Beobachter seiner Umgebung wie auch des globalen Weltzusammenhangs ist Yang Shaobin zum Zeitzeugen geworden, der unberechenbare Zeichen hinterlässt.

Yang Shaobin wurde 1963 geboren und lebte noch 1989 in der Stadt Handan in der Provinz Hebei. Erst 1991 kündigte er in der Porzellanfabrik, in der er als Designer gearbeitet hatte, und zog nach Beijing. Nach einer Weile zog er in das legendäre Yuanmingyuan, das erste Künstlerdorf. Diese Erfahrung gab seiner Karriere einen entscheidenden Impuls, aber Yang

V

Roland Barthes: The relation which unites the concept of the myth to its meaning is essentially a relation of *deformation*. We find here again a certain formal analogy with a complex semiological system such as that of the various types of psycho-analysis. Roland Barthes: Mythologies. Translated by Annette Lavers. London, Vintage 1993, p. 122.

blieb nach seinen erfolglosen Versuchen, sich an der Zentralen Akademie der Schönen Künste in Beijing einzuschreiben, als Künstler Autodidakt.

Seine künstlerische Ausbildung war das Ergebnis seines eigenen Instinkts und seiner Wahrnehmung; seine Kunst berichtet von den Veränderungen, und sie ist auch als gesellschaftliches und politisches Manifest zu verstehen. Seine früheren Arbeiten aus dieser Periode zeigen Gruppen uniformierter Polizisten, deren Gesichter in breites Lächeln zerfließen und so in einem System, das sich veränderte und entzaubert wurde, den Mythos der Uniform als Machtsymbol untergraben. Diese Darstellung lässt sich auch als schicksalhafte Ironie lesen, denn einer von Yang Shaobins ersten Jobs war bei der Polizei, wo er die Erfahrung machte, wie es ist, sich wie ein schlechter Kerl mit Machtmonopol zu benehmen. Durch seine neue Rolle als bildender Künstler konnte er die Rollen umkehren, seine eigene Geschichte abbilden und sich von früheren Gewohnheiten befreien. Eine solche Biografie ist nur in einem System möglich, das sich gerade verändert und das Raum für die Existenz von Individualität zulässt, nach einer Reihe von Enttäuschungen mit dem realen Leben, als ob ein ‚Realismus der Desillusionierung' in seiner Arbeit auftauchen würde.[VI]

Seine Malerei wurde bald anerkannt und seine künstlerische Karriere entwickelte sich im gleichen rasanten Tempo wie Chinas dynamisches Wachstum in den 1990er Jahren. 1993 begann Yang Shaobin international auszustellen, und 1999 wurde seine Arbeit bei der von Harald Szeemann kuratierten Biennale von Venedig in Korrespondenz mit Werken Sigmar Polkes präsentiert. Ein eindrückliches Gegenüber, das starke Resonanz fand.

Yang Shaobin reifte schnell als Künstler und verdichtete unterschiedliche künstlerische Tendenzen sowohl in konzeptueller als auch ästhetischer Hinsicht in seiner Arbeit. Durch persönliche Erlebnisse wie auch seine Erfahrung der Globalisierung entwickelte er sich von seinem zuvor vorherrschenden Sarkasmus zu einer Auseinandersetzung mit zeitgenössischer Gewalt: als ob die Welt um ihn herum eine beispiellose Personifizierung durchmachte. Dieselben Polizisten seiner früheren Arbeiten tragen nicht mehr ihr gekünsteltes spöttisches Grinsen. Sie haben keine klar definierten Gesichtszüge oder den Ausdruck von Ironie mehr, der nun durch die Darstellung von identitätslosen Körpermassen mit animalischen Eigenschaften ersetzt wurde.

Unerbittlich schuf der Künstler eine Serie von Gemälden in tiefem Rot, das an die Farbe der russischen Oktoberrevolution und aller sozialistischen Revolutionen wie auch der chinesischen Kulturrevolution erinnerte.

Als Künstler wurde er von zahllosen politischen Entwicklungen zutiefst beeinflusst. Er konzentriert sich nicht mehr auf den Mikrokosmos seiner eigenen Existenz, sondern betrachtet den globalen Makrokosmos. In dieser Periode bezog er sich immer mehr auf zeitgenössische westliche Kunst, in der er Schlüsselfiguren fand, die dieselbe künstlerische Ideologie vertraten wie er. Yang Shaobin glaubt an kulturelle Symbiose: ‚Ich bin der Meinung, dass das Zusammenwirken der Kulturen in der Kunst genau so wichtig ist wie in den Handelsbeziehungen. Ich sehe eine Kette gegenseitiger Abhängigkeiten, jedes Glied greift in das andere.'[VII]

In seiner Auseinandersetzung mit der Geschichte der zeitgenössischen Kunst findet Yang Shaobin zahlreiche Beobachter mit denselben Anliegen und Sorgen, die ähnliche Darstellungen verwenden. Die deformierten Figuren von Francis Bacon, der ein Leben endloser Kämpfe sowohl auf politischer als auch persönlicher Ebene führte, erzählten von der Zerstückelung von Menschen durch banale oder alltägliche Gewalt. Hermann Nitschs blutgetränkte Akti-

VI

Der Begriff ‚Realismus der Desillusionierung' wurde von Karl Mannheim für einen intellektuellen Trend benutzt, der nach dem Ersten Weltkrieg aufkam und demnach die moderne Gesellschaft im Kollektiv Schutz suchte und es als Fluchtweg ansah. Vgl. Helmut Lethen: ‚Der Kult der Distanz und seine anthropologische Begründung.' In: Hartmut Eggert, (Hrsg.): Faszination des Organischen: Konjunkturen einer Kategorie der Moderne. München, Iudicium, 1995, S. 176.

VII

In einem Interview für den Katalog der Mahjong-Ausstellung. Bernhard Fibicher und Matthias Frehner (Hrsg.): Mahjong. Chinesische Gegenwartskunst aus der Sammlung Sigg. Ostfildern-Ruit, Hatje Cantz, 2005, S. 53.

onen und sein Sezieren von Tieren konfrontierten die Betrachter mit dem Tod und anderen Symbologien, die im Alltag tabu sind. Dieses Thema bringt mich zum mexikanischen Pavillon der diesjährigen Biennale in Venedig, der sich auf die Arbeit von Teresa Margolles konzentriert, deren Stoffe mit Blut und Schlamm von Orten in Mexiko gefärbt sind, an denen die Opfer von Gewalt gefunden wurden. Das Wasser, das von diesen vollgesogenen Stoffen fließt, wird dazu benutzt, den Boden des Palazzo Rota Ivancich zu putzen, wo die Arbeit gezeigt wird. Werden die Wirkungen und brutalen Aspekte der Verirrungen und Widersprüche des modernen Lebens durch die Wirkung der Wiederholung abgemildert? Oder wäre die Wiederholung nicht der einzig effektive Kunstgriff im Kampf gegen das Vergessen? Als Gegenmittel gegen absurde moralistische Interventionen wie die Leugnung des Holocaust? Die Zivilisation braucht lautstarke Persönlichkeiten, die über Disziplinen hinaus transparent agieren und in den Bildenden Künsten, dem Kino oder der Literatur Gewalt verurteilen, um so eine kritische Masse zu erreichen, indem sie ein immer weiter gefasstes Publikum durch ihr Zeugnis erreichen. Hannah Arendt beispielsweise hat ihr ganzes Leben damit verbracht, vor dem Horror des Holocaust zu warnen.[VIII]

Yang Shaobins ,rote' Serie legt Zeugnis über seine Zeit ab und hat nichts von ihrer Aktualität und Vitalität eingebüßt; seit Jahren ist sie ein Schlüsselmotiv seiner Arbeit, obwohl er sie mit Serien in anderen Farben abwechselte. Sie ist sein stärkstes Markenzeichen geworden, das international erkannt und respektiert wird. Das schwer Fassbare der Darstellung von Körpern, der Kontrast zwischen der Wärme des tiefen Rots im Konflikt mit den kühlen weißen Oberflächen, auf denen kein Blut mehr fließt, und der Existenz pinkfarbener Massen durch die Verbindung der beiden Effekte bewirkt zunächst Abscheu. Wenn man Körper auseinandernimmt, zeigt man die Zerbrechlichkeit des Menschen. Aber eine genauere Betrachtung seiner Arbeit zeigt bemerkenswerte und schmerzhafte Ausdrücke wie auch verführerische Torsos voller Vitalität. Jüngere Arbeiten wie ,Who Defaced Me?' und ,Profound Birthmark' enthalten zeitgenössische ornamentale Gegenstände wie Militärflugzeuge in Letzterem, die scheinbar auf die Haut eines Wesens tätowiert sind, das irgendetwas zwischen einem griechischen Gott und einem vom Krieg verstümmelten Menschen darstellt.

Kriegsszenen oder Schlachtfelder sind im Fernsehen oder Kino Allgemeinplätze geworden, und leider auch immer in Nachrichtensendungen präsent. Krieg ist ein ästhetisches Medienspektakel. Besonders nach den Terroranschlägen vom 11. September, die unverzüglich zum Krieg im Irak und Diskussionen in der ganzen Welt führten, standen viele Länder unter Druck, Position zu beziehen. Man sagt, ungefähr 2000 amerikanische Journalisten hätten über den Krieg im Irak berichtet, und fast 500 von ihnen waren vor Ort, bevor Kriegshandlungen überhaupt begannen, um dem Publikum zu ermöglichen, die Ereignisse live zu verfolgen, während sie passierten.[IX] In dieser politischen Schlacht hat Yang Shaobin das Bedürfnis, sich zu äußern. Dann ging er zurück zur Geschichte der Kriege in seinem Land, wie beispielsweise die brutale japanische Besatzung Chinas 1931-1945. Gewalt gebiert Gewalt, und die japanischen Streitkräfte wurden erst aus dem Land vertrieben, als im August 1945 Atombomben über Hiroshima und Nagasaki abgeworfen wurden. Seine Kriegsmotive stammen oft aus den Medien, da diese unerbittlich simultan und authentisch sind. Seine Gemälde kehren zu den Szenarien mit dem Kontrast zwischen hell und dunkel, abstrakt und figurativ zurück. Diese Tendenzen vermischen sich schließlich zu einer Arbeit, und das unklare Wesen des dargestellten Motivs kann als das Ergebnis der dynamischen Handlungen der Protagonisten angesehen werden, die in diese Schlacht involviert sind. Die subtile Anwendung unterschiedlicher Farben mit einer leichten Dominanz von Schwarz vermittelt den Stress des Kriegs.

VIII

,Wenn ich an die zwei Jahrzehnte seit dem Ende des letzten Krieges zurückdenke, habe ich das Gefühl, dass dieses moralische Problem im Schlummer gelegen hat, weil es von etwas zugedeckt war, über das zu sprechen in der Tat äußerst schwierig und das zu begreifen fast unmöglich ist – vom Horror selbst in seiner nackten Monstrosität. Als wir erstmals mit ihm konfrontiert wurden, schien er nicht nur für mich, sondern für viele Andere alle moralischen Kategorien ebenso hinter sich zu lassen, wie er sicher alle juristischen Normen sprengte. [...] Ich habe gewöhnlich gesagt, dass dieses etwas ist, was niemals hätte geschehen dürfen; denn die Menschen werden unfähig sein, es zu bestrafen oder zu vergeben.' Hannah Arendt. *Über das Böse. Eine Vorlesung zu Fragen der Ethik.* Übersetzt von Ursula Ludz. München, Piper, 2006, S. 17.

IX

Siehe Florian Rötzer. ,Der Krieg als ästhetisches Medienspektakel.' In: *Kunst und Krieg. Medienbrüche und epochale Veränderungen. Kunstforum International.* Vol. 8 165, Juni-Juli 2003, S. 53.

Yang Shaobin mag diese Spannung und ein heroisches Gefühl verspürt haben, als er in der Vergangenheit die Polizeiuniform trug. Was immer seine eigene Erfahrung war, zu seiner sozialistischen Erziehung gehörten gewiss fesselnde Parteipropagandabilder von Alltagshelden, mit den Augen eines naiven Kindes betrachtet. Diese Alltagshelden gab es überall in China, in allen Schichten. Um diese Menschen zu ehren, hat Yang Shaobin eine eigene Serie geschaffen, die den Bergleuten gewidmet ist. Ihre Gesichter, gezeichnet davon, dass sie die Tage 800 Meter unter der Erdoberfläche verbringen, lächeln müde – spontan oder künstlich – was zweifellos die Frage ihrer Existenz stellt und des Nationalstolzes, der in der Parteiidentität verwurzelt ist.

Die Frage des Staates gehört zu den Schlüsselthemen von Yang Shaobin. Sein Blick fällt auf unterschiedliche Perspektiven, auch auf die Aktivitäten der Führung. Dies führte zu einer Serie von Gemälden von Staatsoberhäuptern. Fidel Castro, geehrt in einer Serie nach Pressebildern seiner jüngsten öffentlichen Auftritte, hat gewiss eine eindrucksvolle Präsenz. Angesichts der Zerbrechlichkeit seines hohen Alters stellt sich die Frage nach dem Mythos seiner immerwährenden Macht. Der natürliche Verfall seines alternden Körpers mag vielleicht in gewisser Weise dem Verfall des Mythos seiner Rolle und des Systems entsprechen.[X] Yang Shaobin ist ein genauer Beobachter dieser Zusammenhänge, da China und Kuba das gleiche politische System haben. Diese Vertrautheit lässt ihn nach anderen gemeinsamen Manifestationen suchen, die angesichts des hohen Tempos der soziopolitischen Entwicklungen genau analysiert werden müssten. Ihr Echo wird im Westen wie im Osten zu spüren sein.

Wie die Kriegsreporter wird Yang Shaobin weiterhin genau hinsehen und von Ereignissen berichten, ohne sich von den psychischen oder physischen Spuren oder Verstümmelungen abhalten zu lassen. Tatsächlich war eines der Bilder und Episoden, die in jüngster Zeit seine besondere Aufmerksamkeit erregt haben, der Angriff auf den Künstler Martin Kippenberger im Jahr 1979. Damals wurde Kippenberger, einer der Betreiber des legendären Clubs SO36 in Berlin, von einer Gruppe Punker angegriffen. Yang zeigte sein Gemälde ,Strong Face (Martin Kippenberger)' als eines der Schlüsselwerke in seiner letzten Einzelausstellung in Berlin. In diesem Portrait sind Kippenbergers Gesicht und Kopf von Pflastern bedeckt, und einige Wunden sind noch sichtbar. Die ganze Komposition ist in Rot-, Schwarz- und Weißtönen gehalten und konzentriert sich ganz auf die Intensität des Moments. Das Gesicht ist nicht mittig auf der Leinwand platziert, sondern die äußerste rechte Seite bleibt abgewandt. Dünne ausgewaschene Pinselstriche in unterschiedlichen Rottönen verweisen auf das Blut, das bei dem Überfall geflossen ist.

Wo immer er ist, versucht Yang Shaobin, die lokalen Zusammenhänge zu verstehen und auf seine Weise neue Schritte für einen Dialog zwischen Ost und West voranzutreiben. ,Erste Schritte – Letzte Worte' ist seine erste Einzelausstellung in Lateinamerika. Dieser neue Schritt wird auf einen neuen Weg führen.

X

Roland Barthes: ,Die Beziehung, die den Begriff des Mythos mit seinem Sinn verbindet, ist eine Beziehung der *Deformierung*. Man findet hier eine gewisse formale Analogie zu einem komplexen semiologischen System wie dem der Psychoanalyse wieder.' Roland Barthes. *Mythen des Alltags*, Suhrkamp, 1964, S. 103.

▨O Museu de Arte de São Paulo Assis Chateaubriand apresenta a exposição "Primeiros Passos – Últimas Palavras" concebida exclusivamente para esta instituição sendo a primeira mostra de Yang Shaobin no continente latino americano. O enfoque é voltado para sua produção de forma abrangente cobrindo o período de 1996 a 2009.

China passou por um longo período de projeção e reconhecimento internacional nas últimas décadas tendo seu apogeu sediando os Jogos Olímpicos de 2008 na cidade de Pequim. O sistema político permanece o mesmo, o potencial de aquisição do povo chinês

atingiu uma escala inigualável em seu contexto – até o surgimento da atual crise econômica mundial. Todo este cenário é visto e revisto pela arte contemporânea chinesa através da criação de artistas como Yang Shaobin. Atento para seu contexto e o mundo globalizado Yang Shaobin se tornou e permanece um testemunho de seu tempo, o qual deixa rastros imprevisíveis.

Em 1989 Yang Shaobin, nascido em 1963, ainda vivia na cidade de Handan na província de Hebei. Somente em 1991 ele se muda para Pequim abandonando seu emprego de 7 anos como desginer em uma fábrica de porcelana. Após algum tempo se mudou para a primeira vila de artistas, a legendária Yuanmingyuan. Este convívio é um impulso incisivo para sua carreira artística. Contudo Yang Shaobin permaneceu um auto-didata, apesar de tentativas frustradas para ingressar na Academia Central de Belas Artes de Pequim.

Seu instinto e percepção são seus formadores através dos quais passa a relatar a metamorfose vigente, servindo como manifesto político e social. Suas primeiras produções desta época retratam coletivos de policiais uniformizados a se desmancharem em sorrisos largos desfazendo assim o mito do uniforme que os envolve, símbolo de poder em um sistema em plena mutação e dismistificação. Esta representação também pode ser vista como ironia do destino, pois uma das primeiras atividades profissionais de Yang Shaobin foi a de policial, o que lhe deu a experiência do comportamento como um vilão, dono do poder. Através de sua nova atuação como artista plástico ele se permite reverter os papéis, visualizar seu próprio histórico e ainda se libertar de convenções passadas. Esta diversidade de atuações é somente possível em um sistema em transição, o qual passa a dar vazão à existência da individualidade a partir de uma série de desilusões com a realidade como se o "Realismo da Desilusão"[XI] surgisse em sua obra.

A repercussão de sua pintura e a evolução de sua carreira acontecem em curto espaço de tempo com uma rapidez igualável à dinâmica que a própria China vivenciou desde o início da década de 90. A partir de 1993, Yang Shaobin passa a expor internacionalmente, e em 1999 participa da Bienal de Veneza sob curadoria de Harald Szeemann que apresenta seu trabalho em correspondência com obras de Sigmar Polke. Uma contraparte impressionante, que causou muita repercussão.

Yang Shaobin alcança rapidamente seu amadurecimento e desprendimento de tendências artísticas tanto no âmbito conceitual como estético de sua obra. Por questões pessoais e pela vivência globalizada o artista abandona o sarcasmo vingente e se depara com a violência contemporânea: como se ao seu redor o mundo estivesse passando por uma nova e inusitada personificação. Os mesmos soldados de outrora não carregam mais estampado em seus rostos o sorriso forçado de deboche. Os contornos perdem os traços bem definidos e a nítida expressão de ironia acaba dando lugar à reprodução de uma massa corpórea sem identidade própria com características animalescas.

Com lógica impiedosa, o artista criou uma série de quadros em vermelho intenso que lembrou a Revolução de Outubro na Rússia e todas as revoluções socialistas, bem como a Revolução Cultural Chinesa.

Inúmeros fatos políticos abalam o artista. Ele deixa de se concentrar somente no microcosmo de sua existência para visualizar o macrocosmo global. Neste período se aproxima mais e mais da arte contemporânea ocidental onde encontra protagonistas que defendem uma mesma ideologia artística. Yang Shaobin acredita na simbiose cultural: "Minha visão é que em arte a colaboração intercultural é tão importante quanto as

XI

Karl Mannheim chamou de „Realismo da Desilusão" uma tendência intelectual surgida após a Primeira Guerra Mundial através da qual a sociedade moderna passou a procurar apoio no coletivo como mecanismo de fuga. Helmut Letben: Der Kult der Distanz und seine anthropologische Begründung. In: Harmut Eggert. Faszination des Organischen: Konjunkturen einer Kategorie der Moderne. München, Iudicium, 1995, p. 176.

relações comerciais. É uma negociação de dependências mútuas, na qual cada item é contido no outro."[XII].

Somente focando na história da arte contemporânea, Yang Shaobin encontra vários testemunhos em sincronia com suas inquietações, angústias e representação. Os seres gritantes e deformados de Francis Bacon, cuja vida foi acompanhada por infinitas batalhas tanto no âmbito pessoal quanto político, relatam a fragmentação do ser humano como resultado da violência cotidiana. As atuações de Hermann Nitsch banhadas em sangue e o dissecamento de corpos de animais tem o intuito de confrontar o público com a morte e demais simbologias tidas como tabu no dia-a-dia. Esta temática me leva à representação do México na atual Bienal de Veneza com apresentação de Teresa Margolles. A artista apresenta tecidos tingidos de sangue e lama extraídos de locais no México onde foram encontrados cadáveres de vítimas da violência urbana. Estes tecidos sao umedecidos e a água que escorre dos mesmos é utilizada para limpar o piso do Palazzo Rota Ivancich, onde a obra está exposta.

Contradições e aberrações da vida moderna, perdem ou não o seu impacto e brutalidade pelo efeito de repetição? Ou será que esta mesma repetição não seja o único artifício efetivo na batalha contra o esquecimento? Contra depoimentos moralistas absurdos como a negação da existência do holocausto? A civilização necessita de protagonistas de voz ativa que atuem de forma interdisciplinar e transparente na denúncia contra a violência, seja no âmbito das artes plásticas, cinema e literatura entre outros para conquistarem o efeito de massa atingindo um público cada vez maior através de seu depoimento. Hannah Arendt por exemplo passou a vida tentando alertar contra as mostruosidades sofridas no Holocausto[XIII].

A série "vermelha" de Yang Shaobin, testemunha marcante de seu tempo, não perde sua atualidade e vitalidade. Por esta razão ela é há anos motivo presente em sua produção, mesmo que alternada com outras séries de cores distintas. Ela se transformou em sua marca mais forte sendo reconhecida e respeitada mundialmente. A liquidez da representação dos corpos, a dualidade entre o calor do vermelho intenso em contradição com superfícies frias e brancas, onde o sangue não mais flui, a existência de massas roseadas pela junção de ambos efeitos causam no primeiro momento uma grande repugnação. O desfazer dos corpos revela a fragilidade humana. Uma apreciação mais minuciosa de sua obra chega a desvendar entre expressões doloridas e marcantes, torsos sedutores e repletos de vitalidade. Obras recentes como "Who Defaced Me?" e "Profound Birthmark" são acompanhadas de ornamentos contemporâneos como aviões de guerra nesta última. A aeronave surge como que tatuada sobre a pele de um ser cuja existência oscila entre o porte de um Deus grego ou um ser humano mutilado de guerra.

Tanto no cinema como na televisão a existência de um campo de batalha militar incenado já se tornou trivial. Infelizmente sua presença também é constante na realidade dos noticiários diários. A guerra é um espetáculo estético de mídia. Principalmente depois do ataque terrorista de 11 de setembro, o que desencadeou imediatamente a Guerra no Iraque e uma ampla discussão participativa internacional, os Países se vêem pressionados a se posicionar. Há informações de que 2000 jornalistas americanos cobriram a Guerra do Iraque e quase 500 deles fizeram a ocupação territorial antes mesmo do início do conflito a fim de repassarem aos telespectadores a sensação de acompanhar o desenrolar dos fatos ao vivo[XIV]. Yang Shaobin vê no meio desta batalha política sua necessidade própria de manifestação. Ele passa a rever a história bélica de seu País sofrida por exem-

XII

Em entrevista cedida para a publicação da exposição Mahjong. Bernhard Fibicher und Matthias Frehner (EE.): *Mahjong. Chinesische Gegenwartskunst aus der Sammlung Sigg.* Ostfildern-Ruit, Hatje Cantz, 2005, p. 53.

XIII

„Quando penso nas últimas duas décadas desde o final da última Guerra, tenho a sensação, de que este problema moral está se quedou adormecido, porque esta incuberto por algo, sobre o qual é na prática muito difícil se expressar e a sua compreensão é quase que impossível – do horror em si em sua monstruosidade nua. Quando fomos confrontados com ele pela primeira vez, pareceu não somente a mim, mas também para muitos outros como algo que extrapolava todas as categorias morais, assim como excedia também todas as normas jurídicas. (...) Eu já disse que isto é algo, que nunca deveria ter acontecido, pois os seres humanos são incapazes de entendê-lo, puni-lo ou mesmo perdoar. (tradução livre da autora do original em inglês). Hannah Arendt: „Some Questions of Moral Philosophy." *Social Research,* Winter 1994.

XIV

Fonte: Florian Rötzer. Der Krieg als ästhetisches Medienspektakel. In: Kunst und Krieg. Medienbrüche und epochale Veränderungen. Kunstforum International. Vol. 165, junho-julho 2003, p. 53.

plo com a ocupação brutal japonesa entre 1931 e 1945. Violência gera violência e o poder Japonês foi banido somente após o Japão sofrer os bombardeios atômicos nas cidades de Hiroshima e Nagasaki em agosto de 1945. As imagens de motivos bélicos são extraídas pelo artista muitas vezes da mídia, pois esta é implacável em termos de simultaniedade e autenticidade. Suas telas revêm este cenário em um constraste entre o claro e o escuro, abstração e figurativo. Estas tendências chegam a se mesclar em uma única obra e a não nitidez do motivo representado pode ser lida como resultado da ágil dinâmica de atuação dos protagonistas envolvidos nesta batalha. A sutil utilização de cores distintas com uma leve predominância da cor negra decifra a tensão vivenciada no campo de batalha.

Yang Shaobin provavelmente sentiu esta tensão e o gosto do heroísmo ao vestir seu uniforme de policial no passado. Independente desta experiência própria sua formação socialista certamente o encantou, vista por seu ingênuo olhar infantil, com imagens de heróis do cotidiano, utilizados na propaganda partidária. Estes heróis triviais povoavam todo o País e todas as atividades. Como em uma homenagem silenciosa a estas pessoas, Yang Shaobin realizou uma vasta série dedicada aos trabalhadores das minas de carvão. Suas feições camufladas pelas árduas marcas da vivência cotidiana há 800 metros abaixo da superfície da terra revelam espontaneamente ou forçosamente um sorriso desgastado, o qual indiscutivelmente levanta em questão a própria existência e orgulho nacional enraizado em sua identidade partidária.

A indagação sobre a efetividade Estatal também é parte vigente na obra de Shaobin. Seu olhar recai sobre ângulos diversos inclusive ao observar o desempenho dos "senhores de poder". Surge assim uma série de pinturas cujas figuras centrais são chefes de Estado. Fidel Castro é homenageado em uma série extraída de imagens divulgadas pela imprensa sobre suas últimas aparições. Sua presença é indiscutivelmente marcante. A fragilidade de sua idade avançada indaga sobre o mito de seu poder infinito. Teria a deformação natural de seu corpo idoso um paralelo com a deformação do mito de sua atuação e de seu sistema[XV]? Yang Shaobin acompanha atento este contexto, afinal China e Cuba possuem o mesmo sistema político. Esta familiaridade disperta no artista o interesse em desvendar demais possíveis manifestações a serem compartilhadas, as quais devido à agilidade da evolução sócio-política hão de ser analisadas minuciosamente. Seu eco soará no mundo ocidental e oriental.

Yang Shaobin, assim como os repórteres de guerra, continuará a acompanhar e relatar de perto os fatos, sem medo de que seu percurso lhe deixe marcas e mutilações físico-psíquicas. Aliás uma das imagens e contexto que lhe chamou a atenção nos últimos tempos foi a agressão que o artista Martin Kippenberger sofreu em 1979. Naquela época Kippenberger era um dos donos do legendário clube berlinense SO36 e foi atacado por um grupo de punks. Shaobin cria a pintura "Strong Face (Martin Kippenberger)" uma das obras centrais de sua última mostra individual em Berlim. Neste portrait de Kippenberger vê-se sua cabeça e rosto incubertos por curativos e certos ferimentos ainda à vista. Toda composição oscila nos tons de vermelho, negro e branco enfocando na intensidade do momento. O rosto é apresentado descentralizado sobre a tela, sendo que seu extremo direito permanece incógnito. As pincelas ralas e lavadas em tons distintos de vermelho remetem ao sangue que jorrou neste incidente.

Por onde passa Yang Shaobin busca compreender o contexto local e cria a seu modo um novo passo no diálogo entre ocidente e oriente. "Primeiros Passos – Últimas Palavras" é sua primeira mostra individual no continente latino-americano. Este novo passo traçará um novo caminho!

XV

Segundo Roland Barthes: „A relação, que une o termo do mito com seu sistema, é uma relação de *Deformação*. Aqui se encontra uma certa analogia formal em relação a um complexo sistema semiológico como o da psicoanalítica. (tradução livre da autora). Roland Barthes. Mythen des Alltags. Suhrkamp, 1964, p. 103.

I was Wondering No. 2, 2006
Oil on canvas, 193 x 354 cm

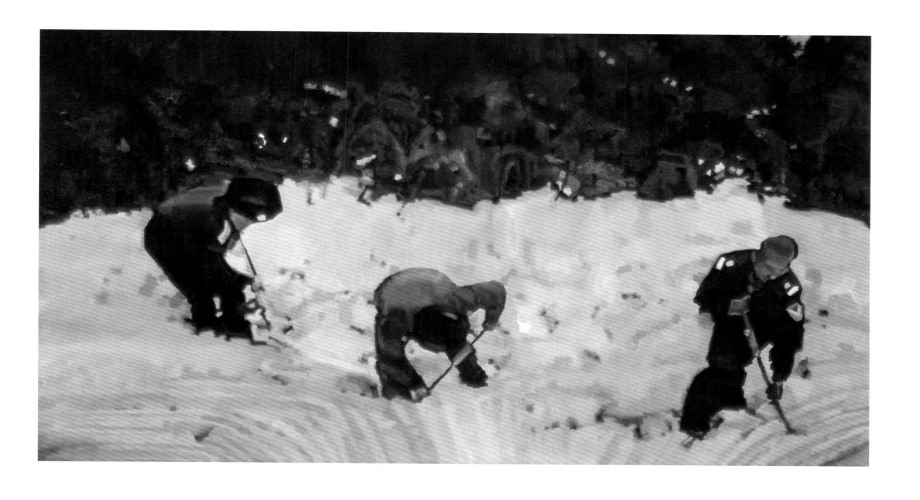

I was Wondering No. 1, 2006
Oil on canvas, 193 x 354 cm

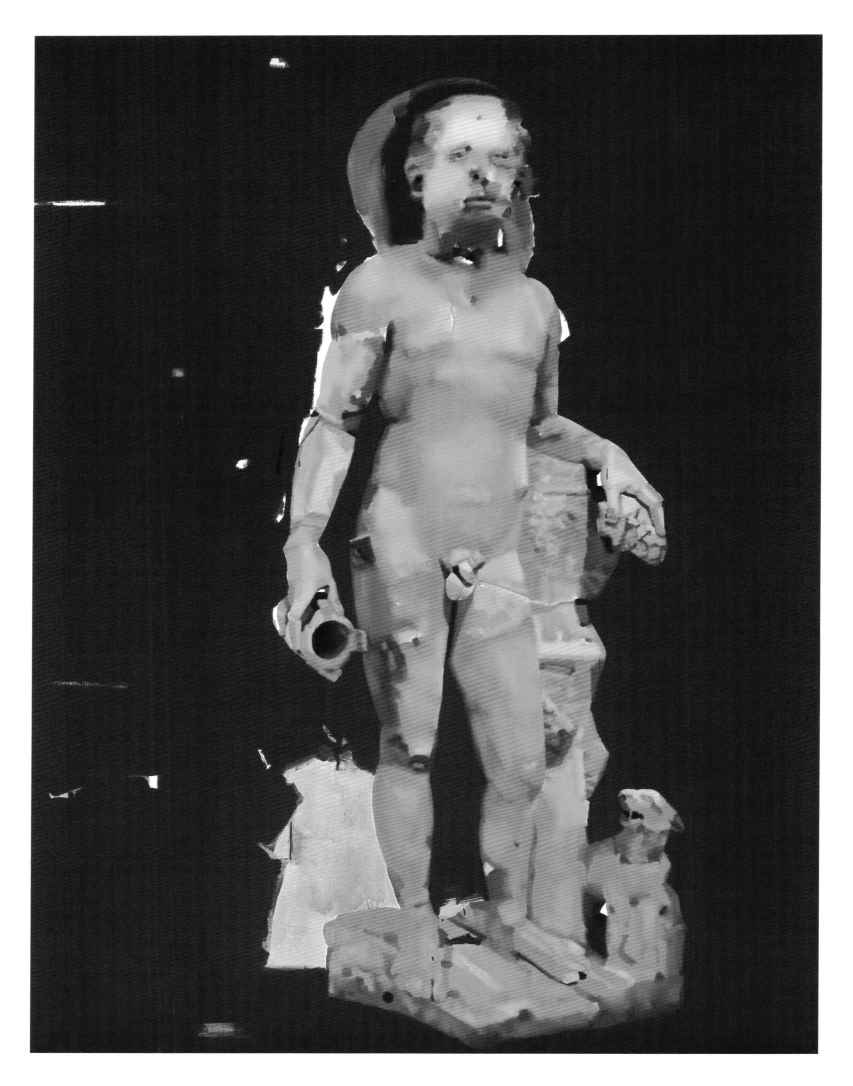

Who Defaced Me?, 2009
Oil on canvas, 280 x 210 cm

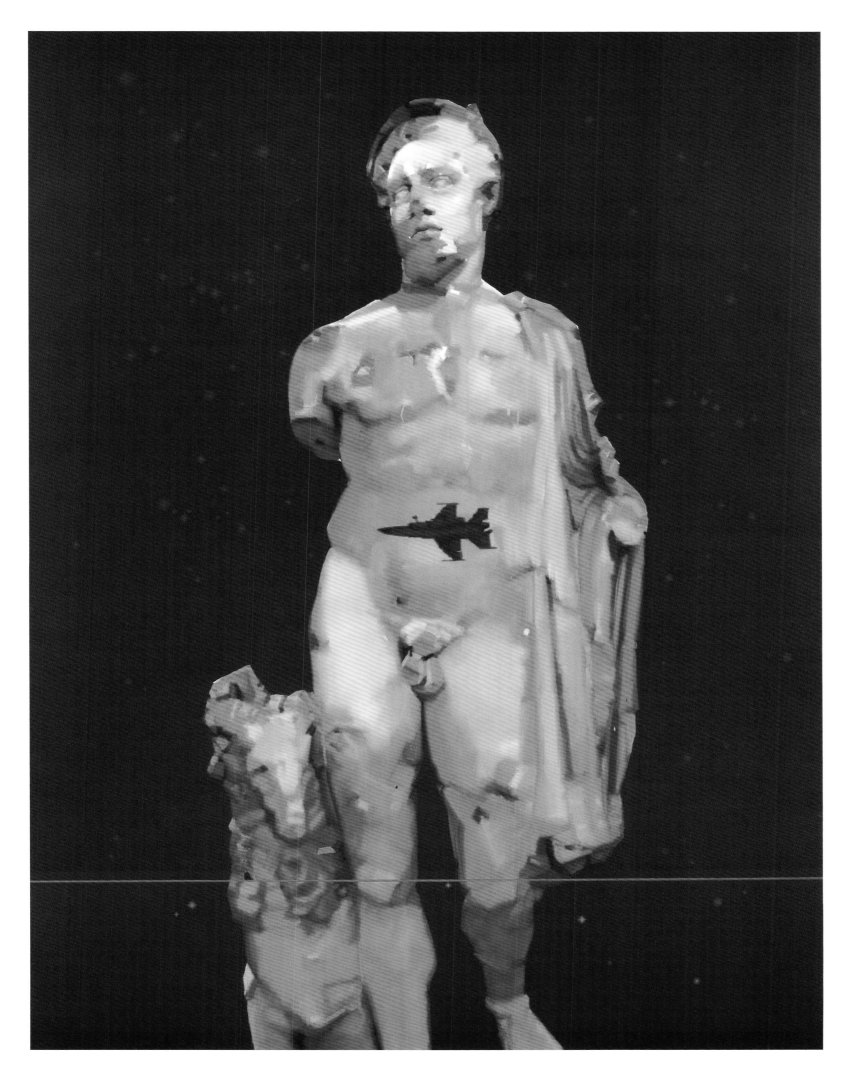

Profound Birthmark, 2009
Oil on canvas, 280 x 210 cm

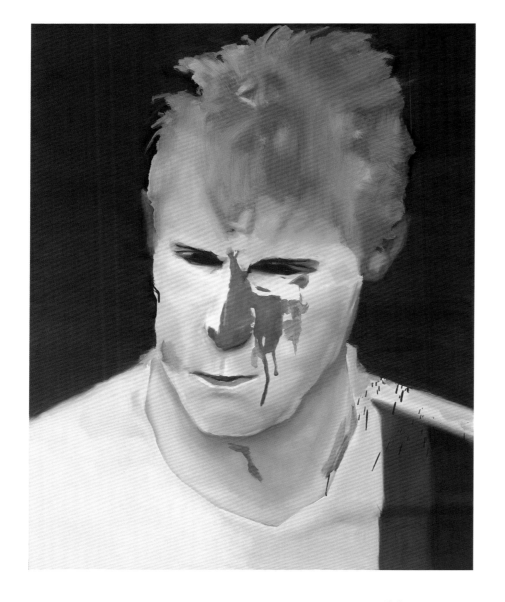

Untitled, 2007
Oil on canvas, 140 x 110 cm

2008.5, 2008
Oil on canvas, 260 x 180 cm

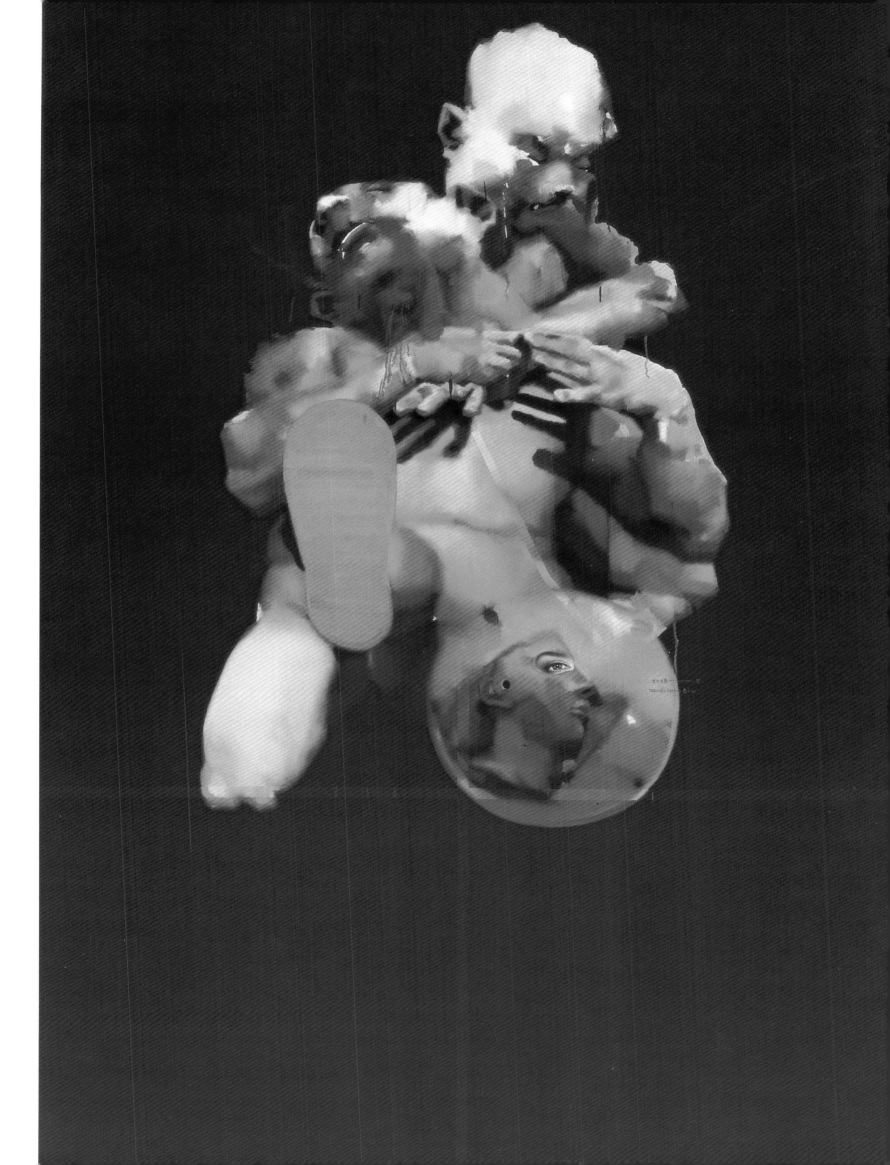

The Road to Death, 2005
Oil on canvas, 110 x 140 cm

Vibrations I, 2005
Oil on canvas, 140 x 170 cm

Is it Safe Here?, 2009
Oil on canvas, 193,5 x 357 cm

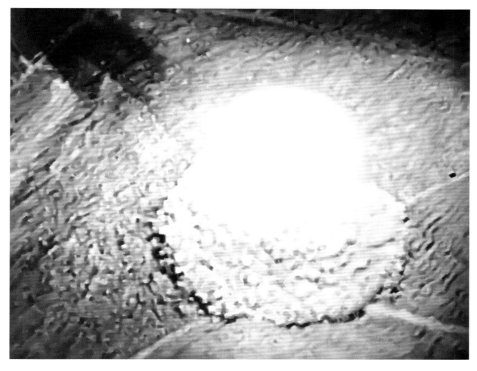

An Egg Impossible to Swallow (2), 2009
Oil on canvas, 80 x 100 cm

An Egg Impossible to Swallow, 2009
Oil on canvas, 80 x 100 cm

Landscape of the Twenty-first Century (Series No. 1-12), 2009
Oil on canvas, 70 x 96 cm

風速達每小時125哩

Landscape of the Twenty-first Century (Series No. 1-12), 2009
Oil on canvas, 70 x 96 cm

Landscape of the Twenty-first Century (Series No. 1-12), 2009
Oil on canvas, 70 x 96 cm

Landscape of the Twenty-first Century (Series No. 1-12), 2009
Oil on canvas, 70 x 96 cm

Landscape of the Twenty-first Century (Series No. 1-12), 2009
Oil on canvas, 70 x 96 cm

Landscape of the Twenty-first Century (Series No. 1-12), 2009
Oil on canvas, 70 x 96 cm

Landscape of the Twenty-first Century (Series No. 1-12), 2009
Oil on canvas, 70 x 96 cm

Landscape of the Twenty-first Century (Series No. 1-12), 2009
Oil on canvas, 70 x 96 cm

p. 87: **Young Hero**, 2009
Oil on canvas, 100 x 80 cm

Without challenge I do nothing. At first I would ask myself: am I capable of overcoming this challenge? My thoughts have gone further now, perhaps because I have aged, I have more capacity to analyze. I proceed slower.

Eine Veränderung ist eine interessante Herausforderung. Heute ist es mir wichtig, dass dem Malen eine Fragestellung vorausgeht. Wenn ich keine Frage habe, male ich auf keinen Fall. Meine Analysefähigkeit hat zugenommen und ich arbeite langsamer.

Toda mudança é um desafio interessante. Hoje faço questão que o ato de pintar seja precedido por um questionamento. Se eu não tenho um quesito, não trabalho de jeito nenhum. A minha capacidade analítica aumentou e o ritmo de trabalho diminuiu.

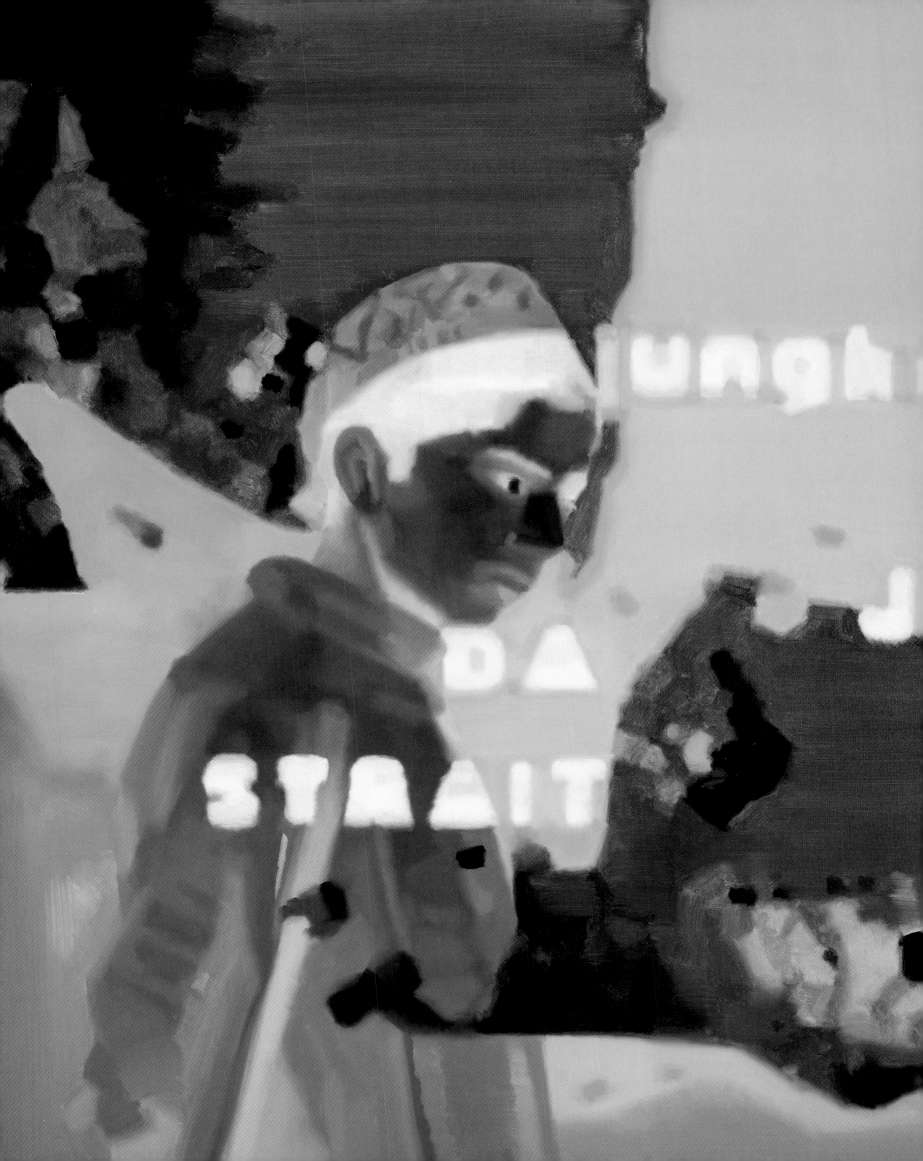

SEBASTIAN PREUSS

THE RED TRAUMA OF VIOLENCE
DAS ROTE TRAUMA DER GEWALT
O TRAUMA VERMELHO DA VIOLÊNCIA

The first encounter remains unforgettable. In the midst of the rush and tumble of the Cologne Art Fair, the noise of the visitors, between countless pointless artworks and all the installations, suddenly these paintings were spellbinding, and all else was forgotten. First, it was a shock to the eyes, but then increasingly an attack on the soul: a kind of painting never before seen. With his red paintings, Yang Shaobin became famous around the world; it is the first highpoint in his work. Basically, at issue is nothing but violence, raw, frightening attacks on the human creature. With a dramatic impact, Yang allows the large, canvas-filling faces almost to explode out of the image. They are not portraits, but rather types, even if also sometimes a certain similarity might surface with the artist's own countenance. The faces are distorted, the mouths opened to tortured screams, the eyes pressed together. Some are deformed, injured, penetrated, as if they had suffered horrific tortures.

No less horrifying are Yang's depictions of whole bodies. But what does whole mean here? They are torsi, mutilated fragments, crippled legs and other body parts, figures in a gruesome uniform or monstrosity. The painter spares us the last details, but there always remains enough to be seen under his expressive strokes to teach the beholder a sense of horror. Men—always men—grab each other brutally in the face, bite their ears or even their genitals, fight and throttle each other, with distorted ugly faces. In an interview, Yang said that during his childhood in a mining area, violence and brutality were omnipresent. This experience haunts him to this day. How people fight, destroy, injure, disrespect, and humiliate one another—this runs through his work like the trace of an eternal Way of the Cross, to use Christian terms.

In his 'red series,' the depiction of violence saturates the work on all levels: in the motifs, in the gestures of the figures, and above all in the painterly aspect. The style is the real sensation of these paintings. It is difficult to believe that Yang came to this style all on his own. In all their nuances and shadings, his paintings are positively saturated with a powerful, brutally glowing red. Everything here is red, the background, the bodies, and faces. Only the hair, if the men have any, is black. Not a contrast, but more a part of the red paint orgy are the white, thin, transparently applied surfaces that lie like poisonous dust on the men and strangely embody their physicality. As if a corrosive acid had rained down on the paintings, the white eats through these faces. The paints are very much thinned, they run and fuse in a highly subtle way. Everything seems somehow liquid; it is as if the concept of Zugmunt Bauman's notion of 'liquid modernity' had here taken form on the canvas. Of course, for Yang at issue is the blood, and in many places the paint runs down as if the figures had just suffered fresh wounds.

The trauma of violence that is released in Yang's paintings in an agitated ecstasy is rooted in the painter's biography: the painter has never denied that. But he also draws from a European-American tradition of expressive art, the examples of which he presents in a

catalogue of 2004 as a reference: a dramatic decapitation scene from the Baroque, the self-destructive Van Gogh, depictions of meat by Chaim Soutine, the deformed bodies of Francis Bacon, tortured figures by Louise Bourgeois, and—what else—a photograph of one of Hermann Nitsch's bloody performances. All of these are the coordinates with which Yang himself marks his painterly terrain, without giving up his own signature style. His equally subtle and expressive brushstroke is unmistakable, just as the fluid application of paint or the way in which the figures are branded into the background.

Despite its idiosyncracies, Yang's painting is an open system and in constant development. In 2003, his paintings became black and grey, and it is astonishing to observe how their dramatics magically froze, the brutality of the event enraptured in a kind of colorist metalevel. It is an almost conceptual transformation of the colors and the iconography, and also a testament to how intensely Yang engages with Western developments. Everything is always in motion, the painterly cosmos in constant expansion. Since 2004–05, Yang has also painted using photographs as models for his paintings, but not in the style of the exact photorealism that has flooded the art market of late, and is often so boring. Again, it is a form of 'fluidization,' the event melts into a coloristic alienation and a seemingly casual, but precisely executed brushstroke.

September 11, 2001 and the Iraq War have led Yang to move from individual violence to violence between states. His painterly paraphrases of photography circle around the Second World War, the bomber attacks of the Japanese on China, the American occupation of Japan, scenes from dictatorships and political conflicts, that need not be precisely localized in order to experience their unsettling effect. His engagement with Gerhard Richter is in this cycle unmistakable. Especially the work 'Vibrations I', with the American bombs, is a reflex on Richter's famous depiction of a Mustang fighter squadron in the traumatic attack on his home city, Dresden.
The critic Ulrike Münter here correctly recognized a subliminal reference to the Germans coming to terms with the Nazi period, something that many Chinese in vain demand of Japan for their war crimes. Yang's paintings based on photographs are certainly not political manifestos, but there are always echoes of concrete political and historical events that are branded onto memory.
Also in his recent series, Yang again approaches the red paintings. Again at issue are destruction and the violent deformation of human bodies. But now they are not just nameless people: there are clear references. So Yang enhances the famous photographs of the dead sons of Saddam Hussein, to a caustic depiction, in which their gruesome death is just as horrific as their bloodthirsty lives. Now there are also references to his illegal visit to a coalmine and its surroundings. Yang there met many deformed children, victims of the catastrophic environmental policies in China. With a frontal view, they indict the hostile world that has produced them. Again, red is the color of trauma.
This is also true for the fiberglass sculptures in which Yang brought his painting with the same expressiveness to three-dimensionality. These sculptures are semi-surreal horror images, half burlesque satyrs engaged in evil play with one another. Yang consciously refers to the grimaces of traditional Chinese demons. The laughing and grinning of these twisted figures betrays an eerie pleasure in violence and attest to the lost of a sense of humanity. The timeless and siteless message is: there is nothing horrific that mankind is not capable of.

Die erste Begegnung ist unvergesslich geblieben. Mitten im Getümmel der Art Cologne, im Lärm der Besucher, zwischen unzähligen nichtssagenden Kunstwerken und all den lauten Installationen zogen auf einmal diese Bilder in Bann und ließen alles andere vergessen. Zuerst war es ein Augenschock, dann aber zunehmend auch ein Angriff aufs Gemüt; eine Malerei, wie sie zuvor noch nicht zu sehen war. Mit seinen roten Bildern wurde Yang Shaobin weltweit bekannt, es ist der erste Höhepunkt in seinem Werk. Im Grunde geht es um nichts anderes als um Gewalt, um rohe, beängstigende Angriffe auf die menschliche Kreatur. Mit dramatischer Wucht lässt Yang die großen, leinwandfüllenden Gesichter schier aus dem Bild hervorschießen. Es sind keine Porträts, eher Typen, wenngleich zuweilen eine gewisse Ähnlichkeit mit dem Antlitz des Künstlers anzuklingen scheint. Die Gesichter sind schmerzverzerrt, die Münder geöffnet zu qualvollen Schreien, die Augen zusammengepresst. Einige sind deformiert, verletzt, durchstoßen, als hätten sie furchtbare Folter durchlitten.

Nicht weniger erschreckend sind Yangs Darstellungen ganzer Leiber. Doch was heißt hier ‚ganz‘? Es sind Torsi, verstümmelte Fragmente, verkrüppelt die Beine und andere Körperteile, Figuren in schauriger Uniform oder Monstrosität. Die letzten Details erspart uns der Maler, aber doch bleibt unter seinen expressiven Pinselstrichen genügend zu sehen, um den Betrachter das Grausen zu lehren. Da greifen sich Menschen – immer sind es Männer – brutal ins Gesicht, beißen sich in die Ohren oder sogar ins Geschlechtsteil, kämpfen und würgen sich mit verzweifelt verzerrten Fratzen. In einem Interview hat Yang erzählt, wie er während seiner Kindheit in der Bergwerksregion Hebei Gewalt und Brutalität als allgegenwärtig erlebte. Diese Erfahrung hat ihn bis heute nicht losgelassen. Wie Menschen sich gegenseitig bekämpfen, sich zerstören und verletzen, missachten und erniedrigen – das durchzieht, um es christlich auszudrücken, sein Werk wie die Spur eines ewigen Kreuzweges.
In seiner ‚roten Serie‘ durchdringt sich die Darstellung der Gewalt auf allen Ebenen: im Motivischen, in der Gestik der Figuren und vor allem im Malerischen. Der Stil ist die eigentliche Sensation dieser Bilder. Kaum kann man glauben, dass Yang sich diese Handschrift als Autodidakt angeeignet hat. In allen Nuancen und Schattierungen sind seine Bilder von kräftigem, ja brutal leuchtendem Rot förmlich durchtränkt. Alles ist hier rot, der Hintergrund, die Leiber, die Gesichter. Nur die Haare, wenn die Männer welche haben, sind schwarz. Keinen Gegensatz, sondern eher einen Teil der roten Farborgie bilden weiße, dünn und transparent aufgetragene Flächen, die sich wie giftiger Staub über die Männer legen und deren Körperlichkeit in merkwürdiger Weise verstärken. Wie der Niederschlag einer ätzenden Säure frisst sich das Weiß durch die Gesichter. Die Farben sind stark verdünnt, verlaufen und verschmelzen in höchst subtiler Weise. Alles erscheint irgendwie liquide; es ist, als habe der von dem Soziologen Zygmunt Baumann geprägte Begriff der ‚flüssigen Moderne‘ hier Gestalt auf der Leinwand gewonnen. Natürlich geht es Yang mit dem Rot um Blut, und an vielen Stellen rinnt die Farbe herab, als hätten die Figuren gerade frische Verletzungen erlitten.

Das Trauma der Gewalt, das sich in Yangs Bildern in aufgewühlter Ekstase entlädt, ist biografisch begründet – das hat der Maler nie verhehlt. Doch schöpft er dafür auch aus einer europäisch-amerikanischen Tradition expressiver Kunst, deren Beispiele er in seinem Katalog von 2004 selbst als Referenz vorführt: eine dramatische Köpfungsszene aus dem Barock, der selbstzerstörerische van Gogh, Fleischdarstellungen von Chaim Soutine, die deformierten Leiber Francis Bacons, gequälte Figuren von Louise Bourgeois, und – wie könnte es anders sein – auch eine Fotografie von einer blutigen Performance des Hermann Nitsch.
Sie alle sind keine unmittelbaren Vorbilder, eher Wahlverwandte, mit denen Yang sich zuwei-

len erst auseinandersetzte, als sich seine eigene Handschrift schon ausgebildet hatte: Koordinaten des eigenen malerischen Terrains. Trotz vieler Ähnlichkeiten mit den genannten Künstlern bleibt Yangs ebenso subtiler wie expressiver Pinselstrich in diesem Umfeld unverkennbar, ebenso der verflüssigte Farbauftrag oder die Art, wie die Figuren sich in den Hintergrund einbrennen.

Yangs Malerei ist ein offenes System und in ständiger Entwicklung. 2003 wurden seine roten Bilder schwarz und grau; und es ist erstaunlich zu beobachten, wie ihre Dramatik magisch eingefroren, ja die Brutalität des Geschehens auf eine Art von koloristischer Metaebene entrückt wird. Es ist eine beinahe konzeptuelle Transformation der Farben und der Ikonografie – auch dies zweifellos ein Zeugnis davon, wie intensiv sich Yang jetzt mit westlichen Entwicklungen auseinandersetzt. Stets ist alles im Fluss, der malerische Kosmos in ständiger Erweiterung. Seit 2004/05 malt Yang auch nach Fotografien, jedoch nicht in einem exakten Fotorealismus, wie er auf dem Kunstmarkt mittlerweile so übermächtig und langweilig geworden ist. Wieder ist es eine Form von ‚Verflüssigung‘, das Geschehen verschwimmt in koloristischer Verfremdung und einem lässig wirkenden, dabei aber höchst präzise geführten Pinselstrich.

Der 11. September 2001 und der Irak-Krieg haben Yang von der individuellen zur zwischenstaatlichen Gewalt geführt. Seine Foto-Paraphrasen kreisen um den Zweiten Weltkrieg, um die Fliegerangriffe der Japaner auf China, um die amerikanische Besatzung in Japan, um Szenen aus Diktaturen und politischen Konflikten, die man nicht unbedingt genau lokalisieren muss, um ihre beunruhigende Wirkung zu erfahren. Die Auseinandersetzung mit Gerhard Richter ist in diesem Zyklus unverkennbar. Besonders das Bild ‚Vibrations I‘ mit den amerikanischen Bombern ist ein Reflex auf Richters berühmte Darstellung einer Mustang-Staffel beim zerstörerischen Angriff auf seine Heimatstadt Dresden am 13./14. Februar 1945. Die Kritikerin Ulrike Münter hat hier wohl zu Recht einen unterschwelligen Verweis auf die deutsche Aufarbeitung der NS-Zeit erkannt, die viele Chinesen bislang vergeblich von Japan für ihre Kriegsverbrechen fordern. Yangs Foto-Nachmalungen sind gewiss keine Manifestbilder, doch schwingen konkrete politische und historische Vorgänge, eingebrannte Erinnerungen immer mit.

Auch in seinen jüngeren Serien nähert sich Yang wieder den roten Bildern an. Erneut geht es um Zerstörung und gewalttätige Deformierung menschlicher Körper. Doch sind es diesmal nicht nur namenlose Menschen, sondern es gibt durchaus konkrete Verweise. So steigert Yang die berühmten Fotos von den toten Söhnen Saddam Husseins zu einer ätzenden Darstellung, in der ihr grausiger Tod ebenso bewegt wie die Erinnerung an ihre blutrünstige Herrschaft zu Lebzeiten. Niederschlag fand jetzt auch der illegale Besuch eines Kohlebergwerks in seiner Heimatprovinz. Dort traf Yang auf zahlreiche missgebildete Kinder, Opfer der katastrophalen Umweltpolitik Chinas. In Frontalansicht klagen sie die menschenfeindliche Welt an, die sie hervorgebracht hat. Wieder ist Rot die Farbe eines Traumas.
Das gilt auch für die Fiberglas-Skulpturen, in denen Yang seine Malerei mit gleicher Expressivität in die Dreidimensionalität überführt hat. Halb sind es surreale Schreckensgebilde, halb burleske Satyrn, die ein böses Spiel miteinander treiben. Bewusst spielt Yang auf die Fratzen traditioneller chinesischer Dämonen an. Das Lachen und Grinsen der verknäuelten Figuren verrät schaurigen Genuss an der Gewalt und kündet vom Verlust eines humanitären Miteinanders. Die zeit- und ortlose Botschaft lautet: Es gibt nichts Grausames, was dem Menschen nicht zuzutrauen ist.

■O primeiro encontro se tornou inesquecível. No meio do tumulto da feira Art Cologne, do barulho dos visitantes, entre inúmeras obras de arte insignificantes e todas as instalações ruidosas, estes quadros repentinamente cativaram a atenção e fizeram esquecer todo o resto. Primeiro foi o choque visual, mas cada vez mais também o ataque ao estado de espírito; uma pintura como nunca havia sido vista antes. Com seus quadros vermelhos, Yang Shaobin ficou conhecido no mundo todo, é o primeiro ápice de sua obra. No fundo trata-se de nada mais do que da violência, de ferozes, tenebrosos ataques à criatura humana. Através de um impacto dramático, Yang faz com que os rostos grandes, que ocupam a tela toda, quase saltem dela. Não são retratos, são mais tipos, que às vezes parecem aludir certa semelhança com os traços do artista. Os rostos são torcidos pela dor, as bocas abertas em gritos de tormento, os olhos cerrados. Alguns são deformados, feridos, perfurados como se tivessem sofrido torturas cruéis.

As representações de corpos inteiros de Yang não são menos assustadoras. Mas o que quer dizer "inteiros"? São torsos, fragmentos mutilados, as pernas e outras partes do corpo aleijadas, figuras em farda horrorosa ou monstruosas. O pintor nos poupa dos últimos pormenores, mas por trás do traçado de seu pincel expressivo ainda fica visível o suficiente para apavorar o espectador. Nos quadros, as pessoas – sempre homens – pegam brutalmente nos rostos do outro, mordem as orelhas ou até o membro genital, lutam e se estrangulam com as caras desesperadamente torcidas. Em entrevista, Yang contou como durante a sua infância, na região de minas Hebei, vivenciou violência e brutalidade como onipresentes. Uma experiência que até hoje não o deixou. Como os seres humanos combatem um ao outro, se destroem e ferem, desrespeitam e humilham – este fato atravessa a sua obra – para usar uma expressão religiosa – como vestígios de uma via sacra eterna.

Em sua primeira "série vermelha", a representação da violência penetra todos os níveis: o dos motivos, os gestos das figuras e principalmente o nível técnico da pintura. No fundo, a sensação destes quadros é o estilo. É até difícil acreditar que Yang tenha desenvolvido esta linguagem própria como autodidata. Em todas as nuances e variações de tons seus quadros são literalmente saturados de um vermelho forte, brutalmente reluzente. Tudo neles é vermelho, o fundo, os corpos, os rostos. Somente os cabelos, dos homens que os tem, são pretos. As superfícies brancas, aplicadas em camada fina e transparente, encobrindo os rostos dos homens feito pó venenoso, não formam contraste, antes fazem parte da orgia vermelha e ampliam o seu aspecto físico de maneira esquisita. Como o sedimento de algum ácido corrosivo, o branco consome os rostos. As cores são muito diluídas, se dispersam e se fundem de maneira extremamente sutil. Tudo parece vagamente líquido, é como se o termo idealizado pelo sociólogo Zygmunt Baumann da Modernidade Líquida tivesse ganho formas na tela. Naturalmente o vermelho de Yang fala do sangue, e de muitos pontos corre a cor, como se as figuras tivessem sofrido novos ferimentos naquele momento.

O trauma da violência, que nos quadros de Yang descarrega em estase desvairada, tem um fundo biográfico, o pintor nunca tentou esconder este fato. Mas para tal ele também explora as fontes de uma tradição européia e americana de arte expressiva, cujos exemplos apresenta em um catalogo de 2004 como referências: uma cena dramática de decapitação do barroco, o auto-destrutivo van Gogh, retratos da carne de Chaim Soutine, os corpos deformados de Francis Bacon, figuras atormentadas de Louise Borgeois e – como

não poderia deixar de ser – uma fotografia de uma performance sangrenta de Hermann Nitsch. Nenhum deles é diretamente ídolo, o mais provável é um parentesco adotado, com os quais Yang por vezes só entrou em diálogo quando sua própria linguagem já tinha se formado: coordenadas de seu próprio terreno de pintura. Apesar de muitas afinidades com os artistas mencionados, o traçado de pincel de Yang continuou inconfundível neste âmbito, assim como a aplicação de cores diluídas ou a maneira como as figuras ficam gravadas no fundo do quadro.

A pintura de Yang representa um sistema aberto em permanente evolução. Em 2003, seus quadros vermelhos se tornaram pretos e cinza é curioso observar como sua dramática ficou magicamente congelada, como a brutalidade dos acontecimentos é desviada para um tipo de "metanível colorístico". Trata-se de uma transformação quase conceitual das cores e da iconografia – com certeza também uma prova da intensidade com a qual Yang atualmente acompanha os desenvolvimentos no ocidente. Tudo está constantemente fluindo, o cosmo da pintura em permanente expansão. Desde 2004/2005, Yang pinta também a partir de fotografias, mas sem o fotorealismo exato, que se tornou tão predominante e repetitivo no mercado de arte. Trata-se novamente de um tipo de liquidificação, o acontecido se desvanece em uma distorção de cores e um traçado de pincel aparentemente descontraído, mas de fato executado de maneira extremamente exata.

Os acontecimentos de 11 de setembro e a guerra do Iraque levaram Yang da violência individual à violência entre os estados. Suas paráfrases fotográficas giram em torno da Segunda Guerra Mundial, dos ataques aéreos do Japão na China, da ocupação americana do Japão, cenas de ditaduras e conflitos políticos que a pessoa não precisa necessariamente de localizar para experimentar seu efeito inquietante. Neste ciclo a análise de Gerhard Richter é inconfundível. Especialmente o quadro "Vibrations I" com bombardeiros americanos, é um reflexo do retrato famoso de uma esquadra de caças Mustang durante o ataque desastroso da sua cidade natal de Dresden, em 13/14 de fevereiro de 1945.
Certamente é com razão que a crítica Ulrike Münter identificou uma alusão do processamento histórico da época nazista por parte dos alemães, que muitos chineses até hoje, e em vão, cobram do Japão por causas de seus crimes de guerra. As pinturas de cópias de fotografias de Yang com certeza não são quadros- manifesto, mas acontecimentos políticos e históricos concretos, marcadas na memória, sempre formando um pano de fundo. Nas suas séries mais recentes, Yang se aproxima novamente aos quadros vermelhos. O assunto é de novo a destruição e a deformação violenta de corpos humanos. Mas desta vez não se trata apenas de seres humanos anônimos, existem referências bem concretas. Yang transforma, por exemplo, as famosas fotos dos filhos mortos de Saddam Hussein em uma representação corrosiva, na qual sua morte cruel comove tanto quanto a lembrança do seu governo sanguinário em vida. A visita ilegal em uma mina de carvão na sua província natal também surtiu resultados. Naquele lugar, Yang deparou-se com numerosas crianças nascidas com deformações, vítimas da desastrosa política ambiental da China. Em perspectiva frontal acusam o mundo cruel que lhes deu à luz. Novamente o vermelho representa a cor de um trauma.
O mesmo vale para as esculturas em fibra de vidro, para as quais Yang transportou sua pintura em terceira dimensão, conservando a expressividade. São metade espantalhos surreais, metade sátiros burlescos que fazem jogo sujo um com o outro. Os risos e a zombaria das figuras entrelaçadas revela um prazer horroroso pela violência e anuncia a perda da convivência humanitária. A mensagem, independente de lugar ou época, é a seguinte: não existe crueldade que o ser humano não seja capaz de cometer.

Happy Life (Series No. 3 - 4), 2009
Watercolour on paper, 36 x 51 cm

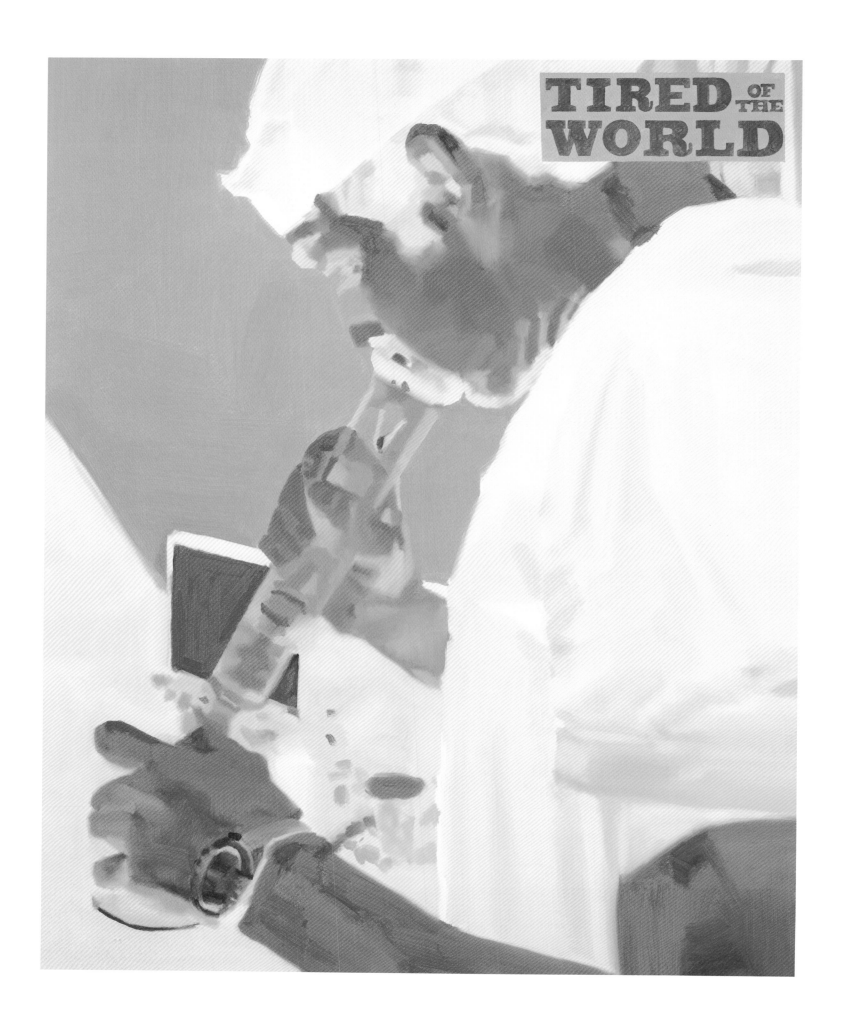

Tired of the World, 2009
Oil on canvas, 100 x 80 cm

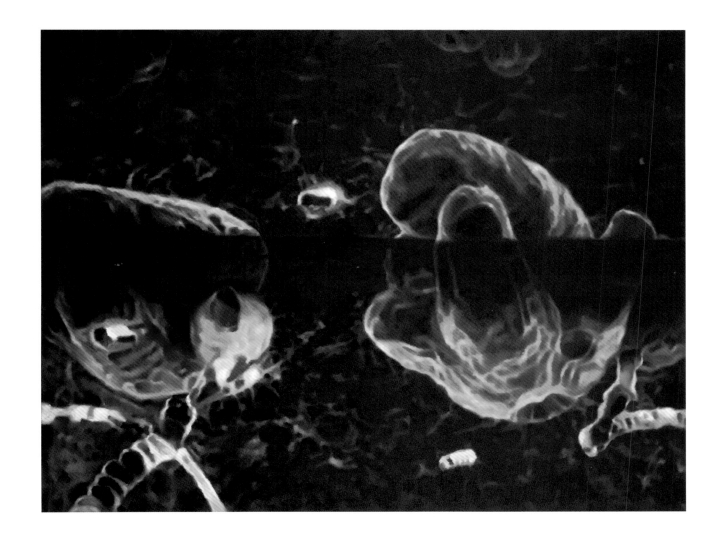

Bad Cells, 2009
Oil on canvas, 110 x 140 cm

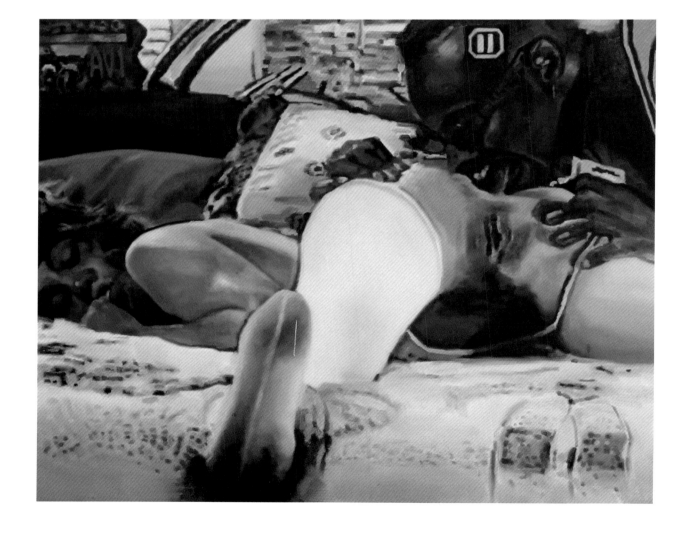

Untitled 3, 2006
Oil on canvas, 130 x 160 cm

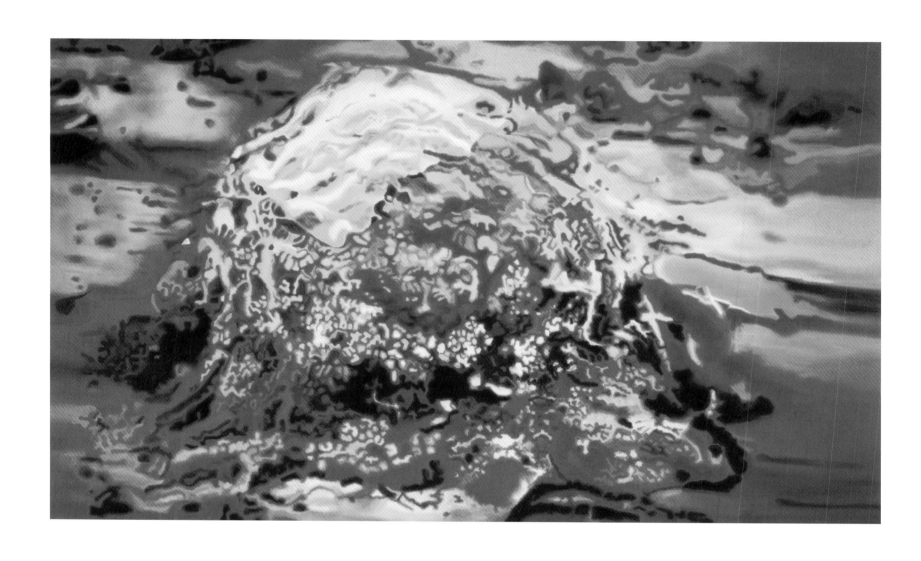

Magnificent Fecundation, 2006
Oil on canvas, 210 x 350 cm

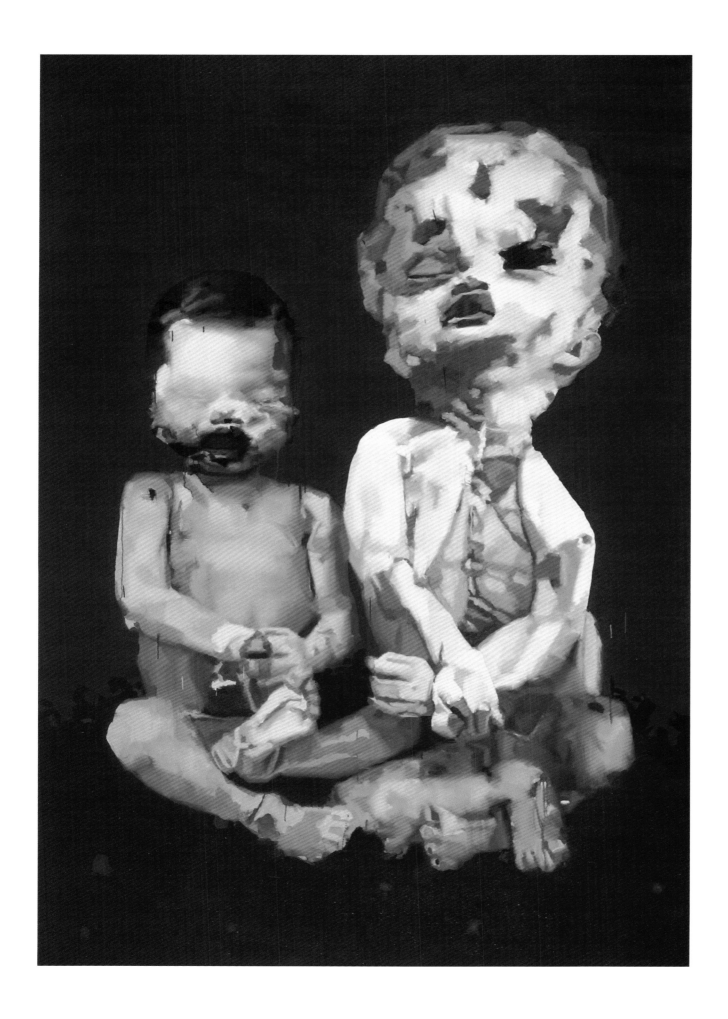

Soon Freezes Male Infant, 2006
Oil on canvas, 260 x 180 cm

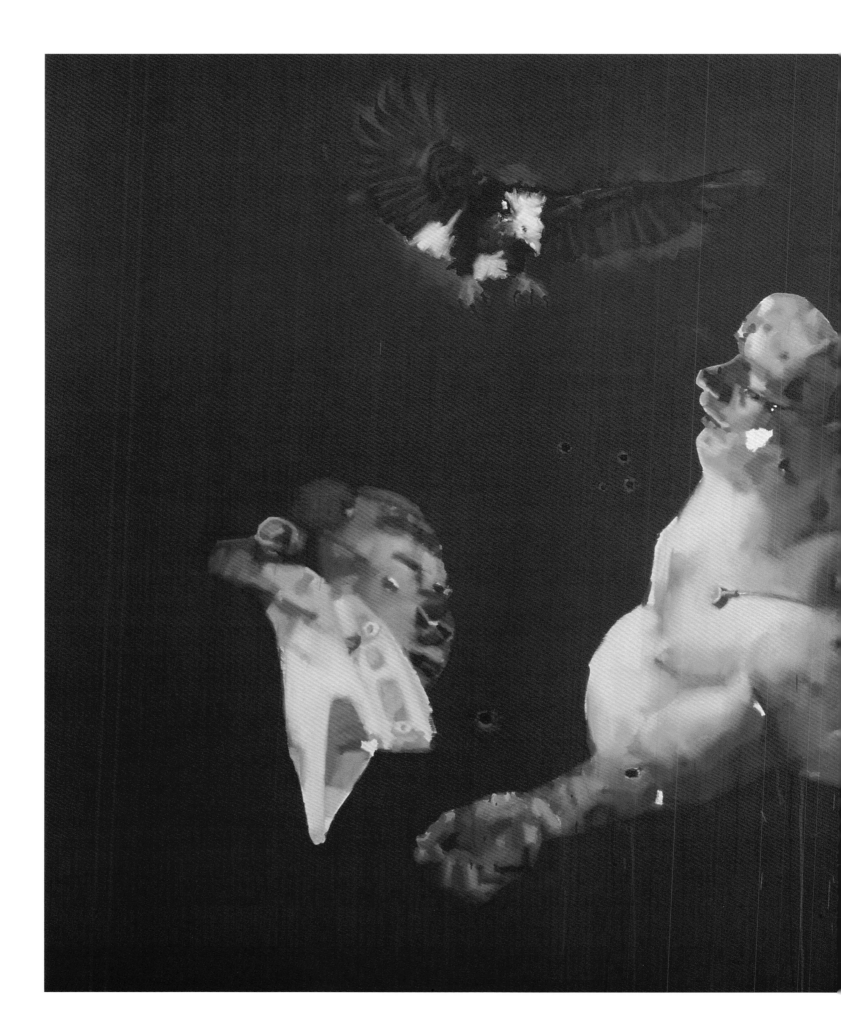

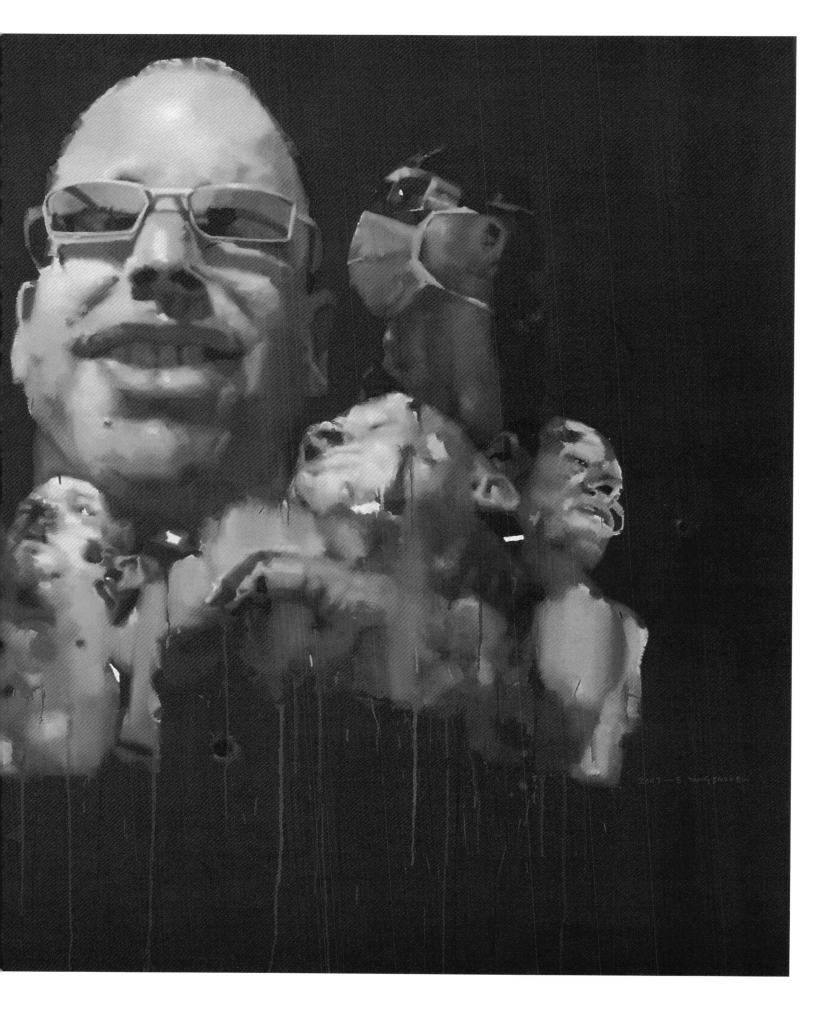

Black Hawk Down, 2007
Oil on canvas, 210 x 350 cm

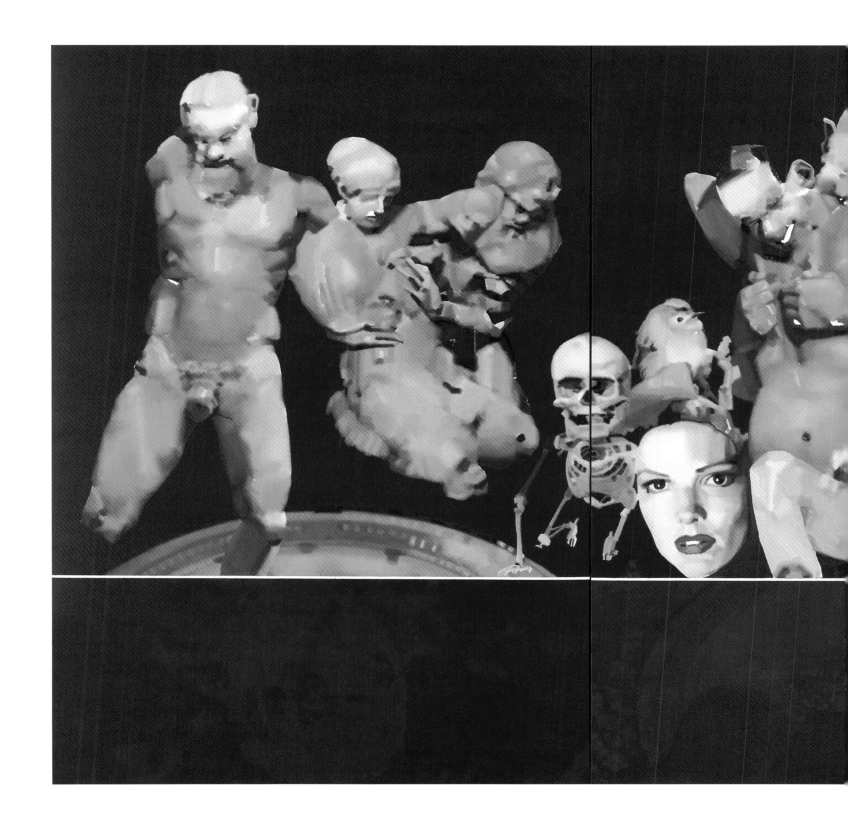

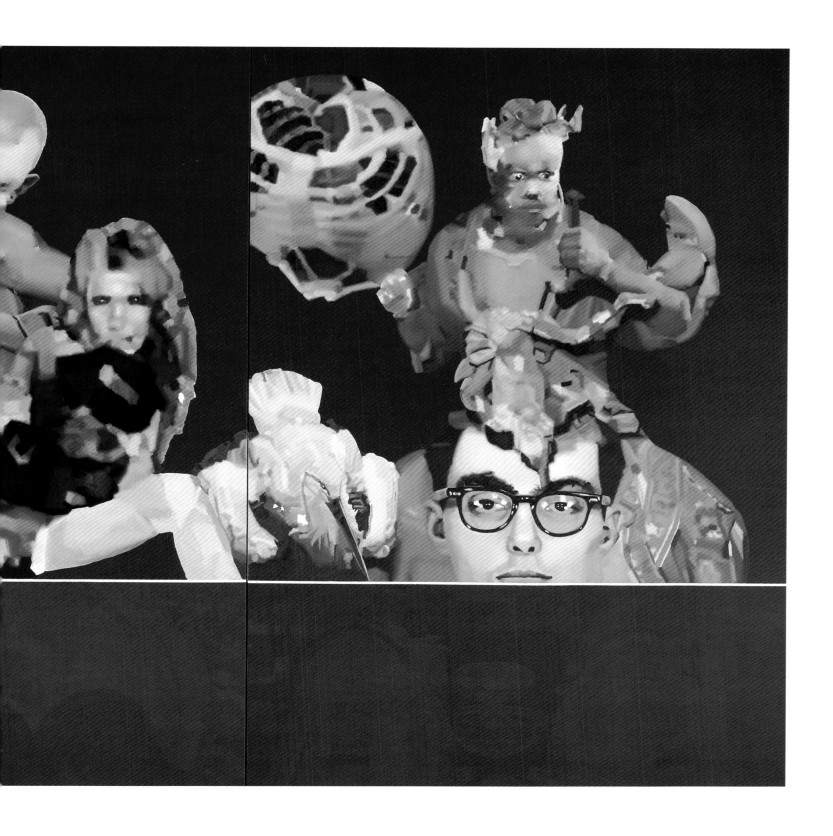

Sleepless Gods, 2009
Oil on canvas, 260 x 540 cm, 3 panels

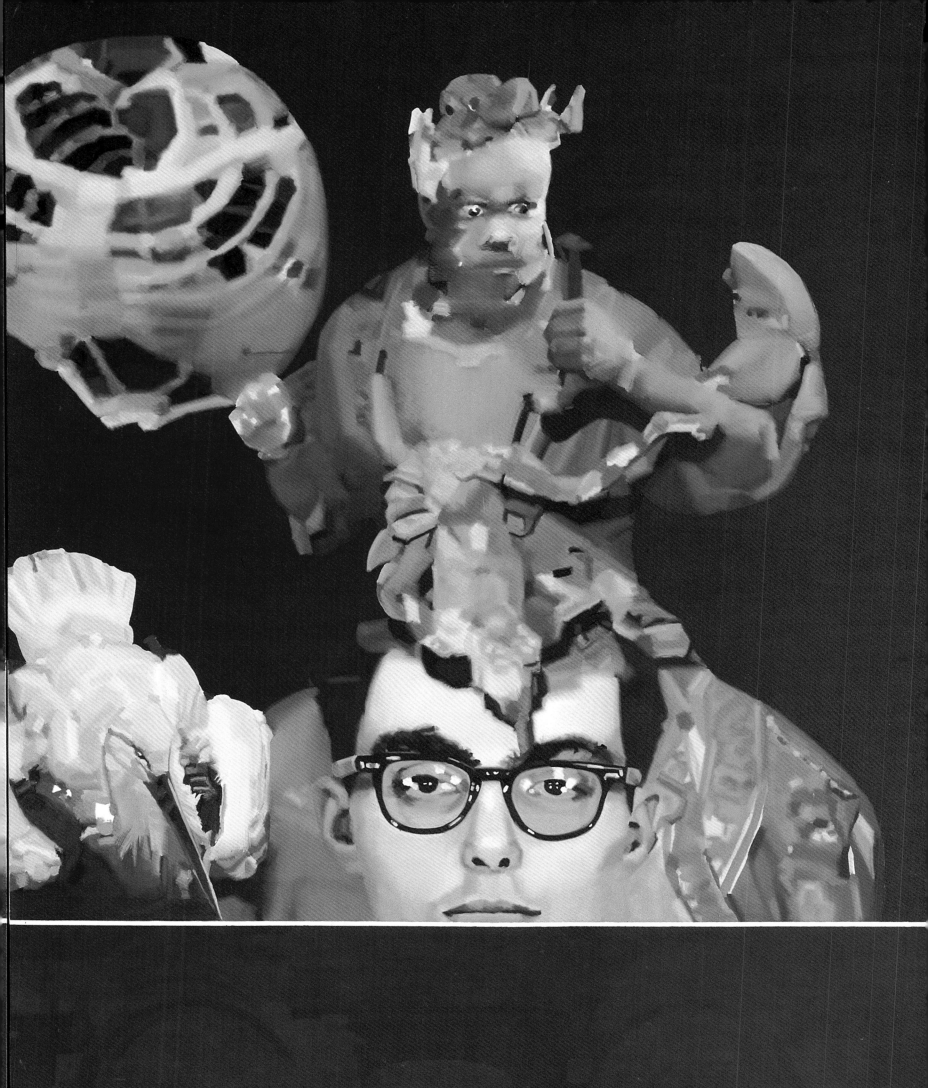

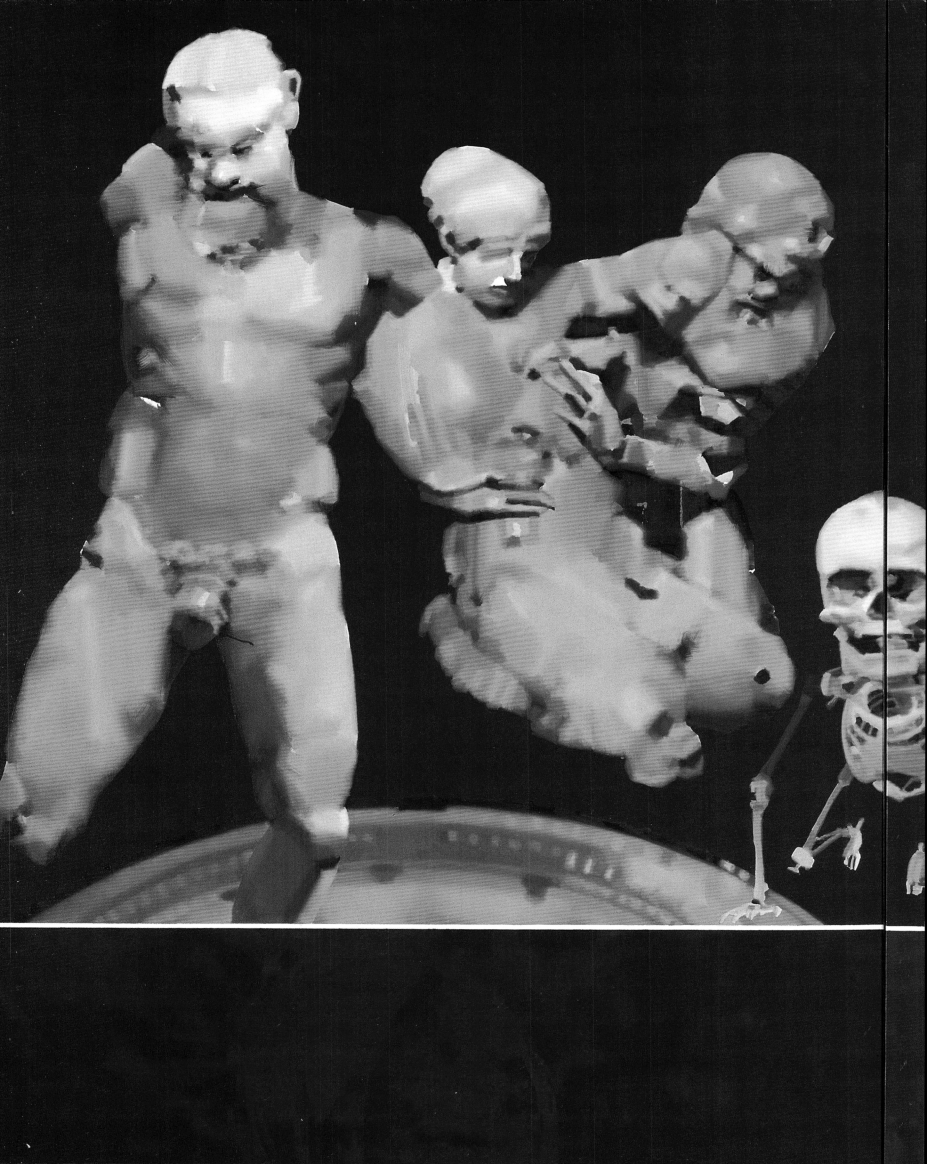

LIST OF WORKS
WERKLISTE
LISTA DE OBRAS

p. 12
Untitled, 1997
Oil on canvas, 41 x 33 cm
Sigg Collection, Switzerland

p. 13
Untitled, 1996
Oil on canvas, 220 x 180 cm
Sigg Collection, Switzerland

p. 14
Untitled, 2006
Oil on canvas, 260 x 180 cm
Collection of CP Foundation, Indonesia

p. 15
Portrait (No. 2), 1997-1998
Oil on canvas, 230 x 180 cm
Sigg Collection, Switzerland

p. 16
2000-8 No. 16, 2000
Oil on canvas, 160 x 140 cm
Private Collection, Germany
Courtesy
ALEXANDER OCHS GALLERIES BERLIN | BEIJING

p. 17
2001-10-31, 2001
Oil on canvas, 140 x 160 cm
Private Collection, Germany
Courtesy
ALEXANDER OCHS GALLERIES BERLIN | BEIJING

p. 18
2000-10 No. 19, 2000
Oil on canvas, 260 x 180 cm
Collection of Zhang Haoming, China

p. 19
2000-12 No. 21, 2000
Oil on canvas, 260 x 180 cm
Private Collection, China

p. 20
Untitled, 1998-1999
Oil on canvas, 230 x 180 cm
Collection of Cheng Xindong, China

p. 21
Untitled, 1998-1999
Oil on canvas, 230 x 180 cm
Collection of Vicki and Kent Logan, USA (fractional
and promised gift to the Denver Art Museum)

P. 22-23
Untitled, 2000
Oil on canvas, 2 panels, each 230 x 180 cm
Sigg Collection, Switzerland

p. 24
Untitled, 1998-1999
Oil on canvas, 230 x 180 cm

Private Collection
Courtesy
Galerie Urs Meile, Beijing-Lucerne, Switzerland

p. 25
Untitled, 1998-1999
Oil on canvas, 230 x 180 cm
Sigg Collection, Switzerland

p. 26-27
Untitled, 1996-1997
Oil on canvas, 260 x 360 cm
Zurich Insurance Company Ltd, Switzerland

p. 29
Untitled, 2000
Watercolour on paper, 36 x 47 cm
Courtesy
ALEXANDER OCHS GALLERIES BERLIN | BEIJING

p. 30
Untitled, 1998
Watercolour on paper, 47 x 36 cm
Courtesy
ALEXANDER OCHS GALLERIES BERLIN | BEIJING

p. 31
Untitled, 2003
Watercolour on paper, 36 x 47 cm
Courtesy
ALEXANDER OCHS GALLERIES BERLIN | BEIJING

p. 32
Untitled, 2002
Watercolour on paper, 47 x 36 cm
Courtesy
ALEXANDER OCHS GALLERIES BERLIN | BEIJING

p. 33
Untitled, 2000
Watercolour on paper, 47 x 36 cm
Courtesy
ALEXANDER OCHS GALLERIES BERLIN | BEIJING

p. 34
Untitled, 2000
Watercolour on paper, 36 x 47 cm
Courtesy
ALEXANDER OCHS GALLERIES BERLIN | BEIJING

p. 35
Untitled, 2002
Watercolour on paper, 47 x 36 cm
Courtesy
ALEXANDER OCHS GALLERIES BERLIN | BEIJING

p. 36
Who, 2006
Oil on canvas, 4 parts, each 53 x 42 cm
Private Collection, Germany
Courtesy
ALEXANDER OCHS GALLERIES BERLIN | BEIJING

YANG SHAOBIN

1963	born in Tangshan, Hebei Province, China
1983	graduated from the Polytechnic University, Hebei
1991	moved to the artist village Yuanmingyuan, Beijing
1995	relocated to Tongxian, in the suburbs of Beijing
2000	Prize for Contemporary Chinese Art (CCAA)
	Lives and works in Beijing

Selected Solo Exhibitions | Ausgewählte Einzelausstellungen | Exposições Individuais Selecionadas

2009	Yang Shaobin: First Steps – Last Words, MASP – Museu de Arte de São Paulo, Brazil
	Yang Shaobin: Silence, ALEXANDER OCHS GALLERIES BERLIN \| BEIJING, Berlin, Germany
2008	X-blind Spot, Long March Space, Beijing, China
2007	Dramas of Violence, National Gallery Jakarta, CP-Foundation, Indonesia
	Yang Shaobin: Immaculata Conceptio, ALEXANDER OCHS GALLERIES BERLIN \| BEIJING, Berlin, Germany
2006	VOCA ME CUM BENEDICTIS, St. Matthäus im Kulturforum, Berlin, Germany
	800 Meters Under, Long March Independent Project Space, Beijing, China
	Hermann Nitsch \| Yang Shaobin, ALEXANDER OCHS GALLERIES BERLIN \| BEIJING, Berlin, Germany
	Hermann Nitsch \| Yang Shaobin, WHITE SPACE BEIJING, Beijing, China
2005	VIBRATIONS, ALEXANDER OCHS GALLERIES BERLIN \| BEIJING Berlin \| Beijing, Germany
2004	Beijing Art Now Gallery, Beijing, China

2003	Grey Paintings, ALEXANDER OCHS GALLERIES BERLIN	BEIJING, Berlin	Beijing, Germany
2001	Loft Gallery, Paris, France		
	Chinese Contemporary Gallery, London, UK		
2000	New paintings from Beijing, ALEXANDER OCHS GALLERIES BERLIN I BEIJING, Berlin, Germany		

Selected Group Exhibitions | Ausgewählte Gruppenausstellungen | Exposições Coletivas Selecionadas

2009	Intempéries (Unwetter), Oca (Pavilhāo Lucas Nogueira Garcez), Parque Ibirapuera, São Paulo, Brazil		
	DOMUS Collection New York	Beijing, WHITE SPACE BEIJING + ALEXANDER OCHS GALLERIES BERLIN	BEIJING, Beijing, China
	Mahjong: Contemporary Chinese Art from the Sigg Collection, Peabody Essex Museum, Salem, Massachusetts, USA.		
	Facing China, Haugar - Vestfold Museum in Tonsberg, Norway / Kuopio Art Museum, Finland / Salo Art Museum, Finland / Ystads Konstmuseum, Sweden		
	19 Games, T ART Center, Beijing, China		
	Body, Shangdong Contemporary Art Center, Nanjing, China		
2008	Mahjong: Contemporary Chinese Art from the Sigg Collection, The University of California, Berkeley Art Museum, Pacific Film Archive, Berkeley, USA		
	Facing China, Stadtgalerie Schwaz, Austria / Kunstraum Innsbruck, Austria / Akureyri Art Museum, Iceland		
	CHINA GOLD, Musée Maillol, Paris, France		
	China, Houston Museum of Fine Art, Houston, USA		
	Himmlischer Frieden (1919-2008), Collegium Hungaricum Berlin, Berlin, Germany		
	Writing on the Wall. Chinese New Realism and Avant-garde in the Eighties and Nineties, Groninger Museum, Groningen, Netherlands		
	Under The Sky, WHITE SPACE BEIJING, Beijing, China		
	Die Wahren Orte II, ALEXANDER OCHS GALLERIES BERLIN	BEIJING, Berlin, Germany	
	The Real Thing: Contemporary Art from China, IVAM, Valencia, Spain		
	Crouching Paper, Hidden Dragon, F2 Gallery, Beijing, China		
	Half-Life, San Francisco Museum of Modern Art, San Francisco, USA		
	Hypallage – The post-modern mode of Chinese Contemporary Art, The OCT Art and Design Gallery, Shenzhen, China		
	7th Shanghai Biennale, Shanghai, China		
	Encounter, PaceWildenstein Gallery, Beijing, China		
	Depth of 800 meters (part of the video) in November, Human rights – Video Art Festival, Australia		
2007	Passion For Art, Museum Essl, Klosterneuburg, Austria		
	BALANCE! KUNST IN HEILIGENDAMM, Bad Doberan, Germany		
	INFERNO IN PARADISE – 10 YEARS ALEXANDER OCHS GALLERIES BERLIN	BEIJING, Berlin, Germany	
	The Real Thing: Contemporary Art from China, TATE Liverpool, UK		
	Zurück zur Figur, Malerei der Gegenwart, Museum Franz Gertsch, Burgdorf, Switzerland		
	Zhi Shang Tan Bing, Square Gallery of Contemporary Art, Nanjing, China		
	Art in Motion, Museum of Contemporary Art, Shanghai, China		
	ARROGANCE & ROMANCE, Ordos Art Museum, Ordos, China		
	BLACK WHITE GREY – An Active Cultural Selection, Today Art Museum, Beijing, China		
	Emotion Aesthetics, dARTex, The Danish Art Exchange, Beijing, China		
	Chinese Contemporary Start, The State Tretyakov Gallery, Moscow, Russia		

2006	CHINA NOW – Kunst in Zeiten des Umbruchs, Essl Museum, Klosterneuburg, Austria
	Mahjong, Chinesische Gegenwartskunst aus der Sammlung Sigg, Kunsthalle Hamburg, Germany
	Zurück zur Figur, Malerei der Gegenwart, Kunsthalle der Hypo–Kulturstiftung, Munich, Germany
	THE SACRED AND THE PROFANE, ALEXANDER OCHS GALLERIES BERLIN \| BEIJING, Berlin, Germany
	Building code Violations, Long March Space, Beijing, China
	CHINA AVANTGARDE, Wiedergeburt des Mystischen, Essl Museum, Klosterneuburg, Austria
2005	Painting Unrealism, WHITE SPACE BEIJING, China
	ASIA: THE PLACE TO BE? ALEXANDER OCHS GALLERIES BERLIN \| BEIJING, Berlin, Germany
	IBCA Prague Biennial, Czech Republic
	Mahjong, Chinesische Gegenwartskunst aus der Sammlung Sigg, Kunstmuseum Bern, Switzerland
	Chinese Sculptures, Museum Beelden aan Zee, Netherlands
2004	China: Bodies Everywhere, Musee d'Art Contemporain, Marseille, France
	Forbidden Senses?, Espace Culturel François Mitterrand, Périgueux, Ancien Evêché, Sarlat, France
	Me! Self-portraits of the 20th Century, Museum of Luxembourg
	Bridge, Siemens Forum, Munich, Germany
	Chinesi!, Potenza Museum, Potenza, Italy
	The Group, Thomas Erben Gallery, New York, USA
	China-Cuba, MACLA Movimiento de Arte y Cultura Latino San Jose, California, USA
	24 Living Artists in China, ALEXANDER OCHS GALLERIES BERLIN \| BEIJING / WHITE SPACE BEJING
2003	CP Open Biennial, Indonesian National Gallery, Jakarta, Indonesia
	Der Rest der Welt, Neuffer am Park, Kunsthalle, Pirmasens, Germany
	Under Pressure, Geneva, Switzerland
2002	De Waan – The Delusion, Stichting Odapark, Center for Contemporary Art, Venray, Netherlands
	First Guangdong Triennial: Reinterpretation, Ten years of Experimental Chinese Art, Guangdong Museum of Fine Arts, China
	Let's go! Chinese Contemporary Artists with the Football World Cup, Millennium Monument Museum, Beijing, China
	Chinese Contemporary Art, Reykjavik, Iceland
	Long March, Upriver Loft, Kunming, China
2001	Abbild, Graz Museum, Graz, Austria
	Dream, Red Mansion Foundation, London, UK
	Hot Pot, Chinese Contemporary Art, Kunstnernes Hus, Oslo, Norway
	Song Zhuang, Städtische Galerie im Buntentor, Bremen, Germany
	First Biennial of Chengdu, Chengdu, China
2000	Bodies/Faces/Icons, ALEXANDER OCHS GALLEIES BERLIN \| BEIJING, Berlin, Germany
	Skin & Space, Spazio Contemporanea Arti e Culture, Milan, Italy
	Futuro, Contemporary Art Center of Macao (CACOM), Macao
	Basic Needs, Expo 2000, Hanover, Germany
	Our Chinese Friends, ACC Gallery Weimar, Germany
	Portraits of Contemporary China, Espace Culturel Francois Mitterrand, Périgueux, France
	Futuro, Contemporary Art Center of Macao (CACOM), Macao
1999	Passage, Dongyu Museum, Shenyang, China
	Art China, Limn Gallery, San Francisco, USA
	48th Venice Biennial, OPERTO OVER ALL, Venice, Italy

1998	Made in China, Nikolaus Sonne Fine Arts, Berlin, Germany
	5000 + 10, Bilbao, Spain
	It's me! Temple of Imperial Ancestors, Beijing, China
	Eight Chinese Artists, Galerie Urs Meile, Lucerne, Switzerland
	Personal Touch, Taida Contemporary Art Museum, Tianjin, China
	First Collection of the Upriver Gallery, He Xiangning Museum, Shenzhen, China
1997	8 + 8-1, Selected Paintings by Fifteen Contemporary Artists, Schoeni Art Gallery, Hong Kong
	The History of Chinese Oil Painting: From Realism to Post-Modernism, Galerie Theorems, Brussels, Belgium
1997	The Eleven's – The Avant-garde, Taikoo Palace, Hong Kong
1996	China Contemporary, Osaka, Japan
1996	China!, Künstlerhaus, Vienna, Austria / Kunstmuseum Bonn / Haus der Kulturen der Welt, Berlin, Germany
1995	Voices from Russia and China, Schoeni Art Gallery, Hong Kong
	Chinese New-Wave Art Exhibition, Conference Center, Hong Kong
	Vision of China: Contemporary Paintings by Chinese Masters, Pacific City Club Bangkok, Thailand
	The Magnificent Duo – Recent Works by Yue Minjun and Yang Shaobin, Schoeni Art Gallery, Hong Kong
	Art Asia'95, Hong Kong Convention and Exhibition Center, Hong Kong
	The Beijing 3: A Three Man Show by Zhang Gong, Yue Minjun, Yang Shaobin, Schoeni Art Gallery, Hong Kong
1994	8 + 8, Contemporary Russian and Chinese Avant-Garde Art Exhibition, Schoeni Art Gallery, Hong Kong
	Faces Behind the Bamboo Curtain – Works by Yue Minjun and Yang Shaobin, Schoeni Art Gallery, Hong Kong
1992	Contemporary Modern Art Exhibition, Friendship Hotel, Beijing, China
	First Exhibition of Professional Artists, Akuna Gallery, Beijing, China

Public Collections | Öffentliche Sammlungen | Coleções Públicas

Cartier Foundation, France

Denver Art Museum, Denver USA

Diözesanmuseum, Würzburg, Germany

Dongyu Museum of Fine Arts, Shenyang, China

Essl Museum/Essl Collection, Klosterneuburg, Austria

Fu Ruide Collection, Netherlands

Guangdong Museum, Guangzhou, China

Kunsthaus, Graz, Austria

Ordos Art Museum, Ordos, China

Reiss-Engelhorn-Museum, Mannheim, Germany

San Francisco Museum of Art, USA

Museum und Kunstkammer Schloss Bartenstein, Schrozberg, Germany

Seoul Modern Art Museum, Seoul, Korea

Sigg Collection, Switzerland

Square Gallery of Contemporary Art, Nanjing, China

Taida Contemporary Art Museum, Tianjin, China

Upriver Gallery, Chengdu, China

Zurich Insurance Company Ltd, Switzerland

Monographic publications | Monographien | Publicações Monográficas

'Yang Shaobin - X-blind Spot', 2008, Long March Writing Group Beijing, China

'Yang Shaobin - The dramas of violence, works from 1993-2007', (curated by Alexander Ochs), 2007, CP Foundation, Jakarta, Indonesia

Zhang Zikang (ed.): 'Yang Shaobin: Essence of violence, Chinese Artists of Today', 2006, Hebei Education Publishing, Beijing, China

'Yang Shaobin - 800 meters under', 2006, Long March Publishing, Beijing, China

Pi Li (ed.): 'Yang Shaobin – Artists of Today', 2006, Sichuan Publishing Group, China

'Yang Shaobin' (Yang Shaobin | Hermann Nitsch), 2006, White Space Beijing and ALEXANDER OCHS GALLERIES BERLIN | BEIJING, Beijing, China

'Yang Shaobin', 2004, Xin Dong Cheng Publishing House, China

'Yang Shaobin, Grey paintings / Red works', 2003, ALEXANDER OCHS GALLERIES BERLIN | BEIJING, Berlin, Germany

Selected publications | Ausgewählte Publikationen | Publicações Selecionadas

Jérôme Sans (ed.): 'China Talks: Interviews with 32 Contemporary Artists from China', 2009, UCCA Publishing, China

Christoph Fein (ed.): 'FACING CHINA, Works of Art from The Fu Ruide Collection', 2008, The Netherlands

Richard Vine (ed.): 'New China New Art', 2008, Prestel Publishing, Germany

Alona Kagan (ed.): 'CHINA GOLD', Musée Maillol Paris, 2008, France

Claudia Albertini (ed.): 'Avatars and Antiheroes – A guide to contemporary Chinese artists', 2008, Kodansha Europe Ltd., Japan

Uta Grosenick, Caspar H. Schübbe (eds.): 'CHINA ARTBOOK', 2007, DuMont Publishers, Germany

Simon Groom, Karen Smith, Xu Zhen (eds.) : 'The Real Thing – Contemporary Art From China', 2007, Tate Publishing, UK

'Passion for Art', Exhibition on the occasion of the 35th anniversary of the Essl Collection, 2007, Edition Essl Collection, Austria

Christina Lange, Florian Matzner (eds.): 'Zurück zur Figur – Malerei der Gegenwart', 2006, Prestel Publishing, Germany

'CHINA NOW – Kunst der Gegenwart, Sammlung Essl', 2006, Edition Essl Collection, Austria

Bernhard Fibicher, Matthias Frehner (eds.): 'mahjong – Contemporary Chinese Art from the Sigg Collection', Text by Karen Smith, 2005, Hatje Cantz Publishers, Germany

'Painting-unrealism' (Curator: Huang Du), 2005, White Space Beijing, China

'Der Rest der Welt' (curated by Alexander Ochs), Neuffer am Park, Kunsthalle Pirmasens, 2003, Germany

'Zhongguo dangdai yishu fang tan lu' (Chinese artists, texts and interviews), 2002, Dongba shiqu chuban (East8 Timezone Press), China

'Song Zhuang, Fang Lijun, Yang Shaobin, Yue Minjun, Li Dapeng', 2001, Städtische Galerie im Buntentor Bremen, Germany

'Lo spazio e la pelle – Catalogo della mostra', 2001, Nicolodi, Italy

'Our Chinese Friends', 2000, ACC-Galerie Weimar, Germany and Skin & Space, Contemporary Art Center Milano, Italy

Szeemann, Harald, Cecilia Liveriero (eds.): La Biennale di Venezia, 48th Esposizione Internazionale d'art. Venice: Edizione La Biennale Venezia and Marsilio, 1999, Italy

ABOUT THE AUTHORS
ÜBER DIE AUTOREN
SOBRE OS AUTORES

UTA GROSENICK

▨ has worked as exihibition manager at the Deichtorhallen Hamburg and the Bundeskunsthalle in Bonn, and was curator at the Kunstmuseum Wolfsburg. She has edited Art at the Turn of the Millennium (1999), Women Artists (2001), ART NOW (2002), ART NOW Vol 2 (2005). Since 2006 she works as editorial director at DuMont Publishers in Cologne, for whom she co-authored International Art Galleries: Post-War to Post-Millennium (2005). Her newest publications are CHINA ART BOOK; PHOTO ART, and Tobias Rehberger 1993–2008.

▨ *hat als Ausstellungsorganisatorin an den Hamburger Deichtorhallen und der Bundeskunsthalle in Bonn gearbeitet und war Kuratorin am Kunstmuseum Wolfsburg. Sie hat Art at the Turn of the Millennium (1999), Women Artists (2001), ART NOW (2002), ART NOW Vol 2 (2005) herausgegeben. Seit 2006 ist sie Programmleiterin beim DuMont Verlag, für den sie INSIGHT INSIDE – Galerien 1945 bis heute (2005) mitverfasst hat. Ihre neuesten Publikationen sind CHINA ART BOOK; PHOTO ART – Fotokunst im 21. Jahrhundert und Tobias Rehberger 1993–2008.*

▨ trabalhou como organizadora de exposições nas Deichtorhallen em Hamburgo e na Bundeskunsthalle em Bonn gearbeitet und e foi curadora no Kunstmuseum Wolfsburg. Ela foi a editora de Art at the Turn of the Millennium (1999), Women Artists (2001), ART NOW (2002) e ART NOW Vol 2 (2005). Desde 2006 é a diretora de programa da editora DuMont Verlag, para a qual foi co-autora de INSIGHT INSIDE – Galerien 1945 bis heute (galerias 1945 até hoje - 2005). Suas publicações mais recentes são CHINA ART BOOK; PHOTO ART – Fotokunst im 21. Jahrhundert (Arte da fotografia no Século XXI) e Tobias Rehberger 1993–2008.

ALEXANDER OCHS

▨ has worked as a freelance curator for Neue Musik. Since 1992 first exhibition projects with Chinese artists, since 1997 he leads galleries in Berlin and Beijing / China. He was curator of several exhibitions in China and Inner Mongolia, and he held lectures at the CAFA, Central Academy for Fine Arts Beijing and the GUGGENHEIM BERLIN. He edited Michael Bach, Fingerbords and Overtones, Edition Spangenberg, 1991, Arrogance & Romance, Ordos Art Museum China, 2007, John Young – Bonhoeffer in Harlem, Edition St. Matthäus Berlin, 2009, amongst others.

▨ *arbeitete als freier Kurator für Neue Musik; 1992 erste Ausstellungen mit chinesischen Künstlern, seit 1997 Galerist in Berlin und Beijing / China; zahlreiche Ausstellungs-Kuraturen in China und der Inneren Mongolei; umfangreiche Vortragstätigkeit u.a. an der CAFA, Central Academy for Fine Arts Beijing und GUGGENHEIM BERLIN, Publikationen u.a. Michael Bach, Fingerbords and Overtones, (Hrsg.), Edition Spangenberg, 1991; Arrogance & Romance, Ordos Art Museum, China, 2007, Hrsg.), John Young – Bonhoeffer in Harlem, Edition St.Matthäus Berlin, 2009 (Hrsg.)*

■ trabalhou como curador livre para Neue Musik (Música Contemporânea); em 1992 primeiras exposições com artistas chineses, desde 1997 galerista em Berlim e Beijing/China; Foi curador de numerosas exposições na China na Mongólia Interior; realizou muitas palestras inclusive na CAFA, Central Academy for Fine Arts Beijing e GUGGENHEIM BERLIN, Publicações, entre outros: Michael Bach, Fingerbords and Overtones, (Editor), Edition Spangenberg, 1991; Arrogance & Romance, Ordos Art Museum, China, 2007, (Editor), John Young – Bonhoeffer in Harlem, Edition St.Matthäus Berlin, 2009 (Editor)

TEREZA DE ARRUDA

■ arbeitet als Kunsthistorikerin und freischaffende Kuratorin, seit 1989 in Berlin, wo sie Kunstgeschichte an der Freien Universität Berlin studiert hat; zahlreiche internationale Ausstellungs-Kuraturen und Koordinierung u.a. Cildo Meireles auf der Documenta11, Copa da Cultura im Haus der Kulturen der Welt/Berlin 2006, Asianart bei den Asien Pazifik Wochen Berlin 2007, Tatsumi Orimoto – Retrospektive und China: Construction/Deconstruction im Museu de Arte de São Paulo 2008, Clemens Krauss Aufwand/Display und Alex Flemming Uniplanetarisches System – In Memoriam Gallileo Gallilei im Museu de Arte Moderna in Rio de Janeiro 2008, The Big World: Recent Art from China im Chicago Cultural Center 2009. Co-Kuratorin der 10° Havanna Biennial und 5° Bienal Vento Sul in Curitiba 2009.

■ works as an art historian and independent curator since 1989 in Berlin, where she studied art history at the Freie Universität Berlin; numerous international exhibitions as curator and coordinator for instance Cildo Meireles at the Documenta11, Copa da Cultura at Haus der Kulturen der Welt/Berlin 2006, Asianart at the Asien Pacific Weeks Berlin 2007, Tatsumi Orimoto – Retrospective and China: Construction/Deconstruction at Museu de Arte de São Paulo 2008, Clemens Krauss Aufwand/Display and Alex Flemming Uniplanetarisches System – In Memoriam Gallileo Gallilei at Museu de Arte Moderna in Rio de Janeiro 2008, The Big World: Recent Art from China in Chicago Cultural Center 2009. Co-curator at the 10° Havanna Biennial and 5° Bienal Vento Sul in Curitiba 2009.

■ trabalha como historiadora de arte e curadora independente desde 1989 em Berlim, onde estudou história da arte na Universidade Livre de Berlim; inúmeras curadorias e coodenação de mostras internacionais entre outras Cildo Meireles na Documenta11, Copa da Cultura na Casa das Culturas do Mundo em Berlim 2006, Asianart no Asien Pacific Weeks Berlim 2007, Tatsumi Orimoto – Retrospectiva e China: Construção/Desconstrução no Museu de Arte de São Paulo 2008, Clemens Krauss Aufwand/Display e Alex Flemming Sistema Uniplanetário – Em Memória Gallileo Gallilei no Museu de Arte Moderna no Rio de Janeiro 2008, The Big World: Recent Art from China no Chicago Cultural Center 2009. Co-curadora da 10° Bienal de Havana Biennial e 5° Bienal Vento Sul em Curitiba 2009.

SEBASTIAN PREUSS

■ studied art history, history, French in Berlin, Cologne, Bonn and Mainz/Germany and works as a journalist since 1989, he has written for the Frankfurter Allgemeine Zeitung. Since 1997 he has been an art critic for the Berliner Zeitung. He has published in catalogues and magazines such as art, Monopol, Architectural Digest, Museumskunde and Humboldt.

■ studierte Kunstgeschichte, Geschichte, Französisch in Berlin, Köln, Bonn und Mainz. Ab 1989 als Journalist tätig, freier Mitarbeiter der Frankfurter Allgemeinen Zeitung, seit 1997 Kunstkritiker der Berliner Zeitung. Er publizierte in Katalogen und Zeitschriften wie art, Monopol, Architectural Digest, Museumskunde und Humboldt.

■ cursou História da Arte, História e Francês nas Universidades de Berlim, Colônia, Bonn e Mainz na Alemanha, e desde 1989 é jornalista, trabalha como free-lance para a Frankfurter Allgemeine Zeitung. Desde 1997 é crítico de arte para a Berliner Zeitung. Publicou catálogos e revistas como art, Monopol, Architectural Digest, Museumskunde e Humboldt.

IMPRINT
IMPRESSUM
IMPRESSO

This catalogue is published on the occasion of the exhibition
Diese Publikation erscheint anlässlich der Ausstellung
Este catálogo é publicado por ocasião da exposição
Yang Shaobin | First Steps – Last Words | Primeiros Passos – Últimas Palavras

MUSEU DE ARTE DE SÃO PAULO ASSIS CHATEAUBRIAND – MASP
August 13th – October 18th 2009

The Portuguese edition is supplemented with a text by | Der portugiesischen
Ausgabe liegt ein Text bei von | A edição em português conta com um texto do
Prof. Dr. José Teixeira Coelho Netto

Editors | Herausgeber | Editado por
Uta Grosenick & Alexander Ochs

Authors | Autoren | Autores
Uta Grosenick
Alexander Ochs
Tereza de Arruda
Sebastian Preuss

Editorial Office | Lektorat | Editorial
Iris Scheffler, Zhang Jue

Translations | Übersetzungen | Traduções
Brian Currid
Frank Sabitzer
Wilhelm von Werthern

Graphic Design | Grafische Gestaltung | Design Gráfico
Dorka Kopcsányi, Berlin, Germany

Production | Gesamtherstellung | Produção
ALEXANDER OCHS GALLERIES BERLIN | BEIJING +
Dorka Kopcsányi, Berlin, Germany

Photo credit | Bildnachweis | Crédito Fotográfico
p. 7, p. 108 Maurice Weiss, OSTKREUZ Agentur der Fotografen GmbH, Berlin, Germany

Special thanks to | Dank an | Agradecimento
Josette Balsa, Rita & Uli Sigg

Thanks to | Wir danken | Agradecimento
Guillaume Gautrand, Marianne Heller, Hans-Olaf Henkel, Catherine Kwai, Urs Meile,
Leng Lin, Rainer Lingenthal, Lu Jie, Tian Yuan, Zhang Di, Zhang Haoming, Zhu Di

© 2009 DuMont Buchverlag, Köln
www.dumont-buchverlag.de
ALEXANDER OCHS GALLERIES BERLIN | BEIJING
www.alexanderochs-galleries.com
All rights reserved | Alle Rechte vorbehalten | Todos os direitos são reservados

ISBN 978-3-8321-9265-5
Printed in China